D0565181

Creating Exhibition-Quality Digital Prints

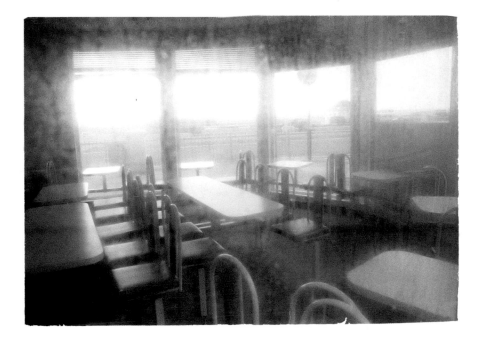

Tim Daly

Creating Exhibition-Quality Digital Prints

argentum

First published 2008 by Argentum,
an imprint of Aurum Press Ltd,
7 Greenland Street,
London NW1 0ND

Copyright © Tim Daly 2008

The right of Tim Daly to be identified as the author of this work has
been asserted by him in accordance with the Copyright, Designs and
Patents Act 1988.

All rights reserved. No part of this book may be reproduced or
utilised in any form or by any means, electronic or mechanical,
including photocopying, recording or by any information storage and
retrieval system, without permission in writing from Aurum Press Ltd.

A catalogue record for this book is available from the British Library.

ISBN-10 1 902538 50 1
ISBN-13 978 1 902538 50 1

10 9 8 7 6 5 4 3 2 1
2012 2011 2010 2009 2008

Printed by SNP LeeFung, China

Designed by Nina Daly

Contents

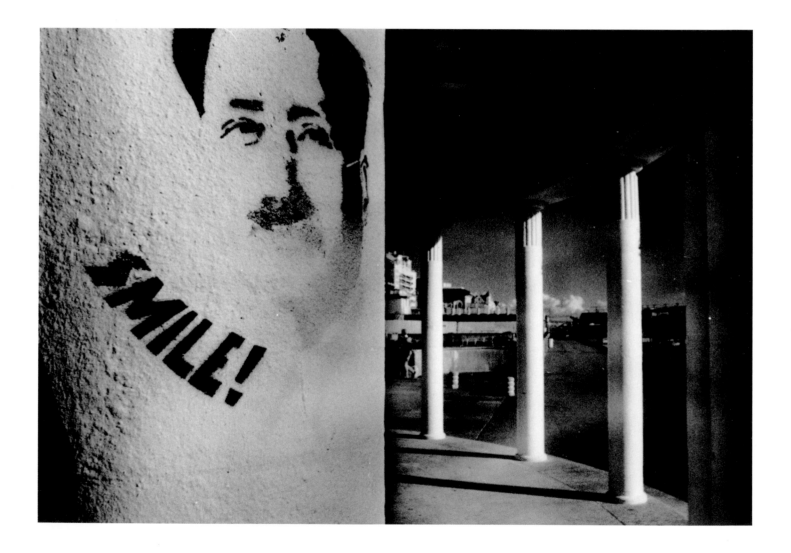

The secrets of hand-editing

Great photographic prints are made by the foresight, intuition and dexterity of a creative practitioner, not by software trickery.

The craft of digital printing is still in its infancy, but already expert practitioners are becoming known for their own unique approaches to image-editing and innovative editing sequences. Now that the technology of capture, processing and output has stabilised, skilled operators have started to create their own individual styles and are looking back to traditional darkroom skills for inspiration.

Digital photography is now at an interesting crossroads. With so many social networking websites and camera phones in use, many images never make it to the print-out stage, remaining virtual and ultimately impersonal.

This book aims to elevate the status of the digital print, by providing a range of inspirational ideas, projects and principles to encourage you to bring your digital files to fruition and make permanent the otherwise invisible results of your creative practice. Digital image files are not meant to sit within your hard disk for their entire lifetime, they need to be celebrated and enjoyed by others.

Skills learned by drawing and painting, with pen, paint or even light can have a bearing on the quality and appearance of the final print. *Creating Exhibition-Quality Digital Prints* provides in-depth instruction and advice on how to develop this hand-crafted look and assumes no prior knowledge of printing on the part of the reader.

The very best photographic prints, both traditional and digital, are defined by the visual interest caused by tonal variation, random pattern and hand-rendered marks. To improve your printing skills and to develop your own personal style, it's essential to start driving your software applications rather than being driven by their inherent limitations. Many talented photographers are too easily constrained by processes laid down by software, not by any underlying personal principles or painterly concerns. In practice, it should be the other way round, you alone should determine the end-result, not your tools.

Creating Exhibition-Quality Digital Prints aims to develop your understanding, skills and knowledge of hand-crafted image-editing and shows you how to approach the conceptual development of your final print, in addition to its technical realisation. Develop your idea first, then use all the tools available to make the journey.

Using the now industry-standard software for image editing, Adobe Photoshop, this book uses common tools and processes found in all recent versions of this application. The book also uncovers the benefits of working with the new RAW file workflow and shows you how to organise, develop and print your photographs using the latest application aimed at professional photographers, Adobe Photoshop Lightroom.

Creating Exhibition-Quality Digital Prints, was preceded by two companion volumes: *The Digital Printing Handbook* and *The Digital Colour Printing Handbook*.

Both books are designed to instill the fundamentals of file preparation, colour management and colour control in a jargon-free manner and to provide an ideal resource for keen digital printmakers.

Celebrate your work through your own carefully considered approach to printing and you will never be disappointed with the results.

Chapter 1

PRINT STYLES AND FORMATS

The mechanical print

Produced by the ubiquitous mini-lab, mechanical prints offer little subtlety or craftsmanship, but do provide a low-cost and permanent printing solution.

Mini-lab print output has embraced digital technology in the last few years by adapting to consumer demand for low-cost convenience printing. This kind of photographic output still relies on silver-based photographic printing papers and chemistry but offers a host of additional software enhancements to source images. Most modern mini-labs beam the digital image onto light-sensitive receiving media which is then developed and packaged for the client. Yet, this modern adaptation of a forty-year-old process does have some new advantages.

On receipt of the client's image files, be they supplied online or through a high street kiosk terminal, most digital mini-labs impart additonal software enhancements to the file, such as contrast correction, colour balancing and sharpening. Aimed at serving the amateur compact camera user, these enhancements can create a very different result to the one expected and should not be used to provide finished prints.

The advantages of using a mini-lab service are speed, affordability and the permanence of the end-result. Life expectancy of modern day silver-based colour papers easily exceeds fifty years, making them a good option for proof prints or large-volume commercial work. Although the number of dedicated retail outlets for photo-processing has declined

in the last five years, together with specialist professional labs, online access to these services has shown a steady increase.

A typical budget mechanical print, where a range of automatic software enhancements have been applied, can be characterised by visible sharpening and high-contrast shape edges that look almost raised. In addition to this, colour saturation could be lower than expected, together with some flat tonal areas.

Getting the best out of the service

With the ability to upload digital image files from the convenience of your desktop, making a car journey to the photo-lab is a thing of the past. Best results are gained when each individual image is prepared and processed by the photographer rather than relying on automated enhancements at the mini-lab. Professional laboratory services provide clear guidelines on supplying image files for print-out and make clear recommendations about sharpening and the pixel dimensions of your source files.

For output from a typical digital mini-lab, prepare your image resolution at 200 pixels per linear inch of print and no less, or you will see the tell-tale signs of blocky pixel shapes in your print-outs. If you are shooting and storing image files with a

pixel resolution of 3000 x 2000, you will be able to make top quality mini-lab prints up to 15 x 10 inches in size.

Prior processing

Although the quality of digital mini-lab output far exceeds that of its analogue predecessors, there are several essential edits to make before submitting your files.

Firstly, ensure that the aspect ratio of your file matches your targetted print shape, or you will suffer the consequences of an automated crop. With no standard image sensor in use, unlike the universal 35mm film format shape, modern digital cameras produce a variety of differently shaped files. Better online labs offer a print preview function through their browser-based uploading, so you can see if and where a crop may be applied.

Next, ensure any excessive light, dark or flat tonal aras have been enhanced to provide the kind of emphasis that you desire. No mini-lab will ever correct washed-out skies or rescue detail from a black hole in your image file.

Finally, package your file as a high quality JPEG to provide faster transmission over your network without losing too much quality. Save and store your original files as RAW or TIFF and remove all prior processing edits so you can interpret the file in the future from exactly the same starting point.

Mini-lab edited

This illustration above shows an unprocessed file as output by a digital mini-lab. Notice the absence of emphasis and unsaturated colours. Mechanical output rarely enhances image files that need creative editing in order to fulfil their potential. On difficult files, better results are gained by applying a sequence of hand-edits.

Hand-edited

This example, right, was produced using simple editing techniques in Photoshop, including a gradient editor enhancement to make the sky more blue and darker at the top, together with an increase in colour saturation to make the scene more vivid. Both of these edits increase contrast without causing printing problems.

The hand-print

Sculptural light never exists on location, but carefully crafted hand-printing skills can extract the maximum amount of emphasis from a less than perfect starting point.

Looking at the monumental American landscapes of Ansel Adams or the near-biblical scenes from Sebastian Salgado's Serra Pelada series documenting the Brazilian gold mines, it's easy to think that both photographers bore witness to extraordinary meteorological events. Shafts of light, deep black skies and perfect contrast reveal extraordinary subjects in a hyper-real environment. Yet, on closer examination of their practices, it's apparent that both photographers relied heavily on the delicate craft of hand-printing, as well as the dark art of chemical manipulation.

Hand-printing techniques exist to rescue, resuscitate and reveal the maximum impact of your RAW files, to fulfill your purpose and deliver your stylistic concerns. They allow you to add contrast where none exists, create tonal interest where only flat areas prevail and tweak colours to create harmony and balance. Hand-printing places your own personal 'signature' on otherwise nameless files.

Digital processing software has been designed to pull together the many strands of darkroom and laboratory skills accumulated over the last 160 years, providing unparalleled creative opportunities. Yet, despite the relentless development of products and plug-ins, great prints are first made in the mind of the photographer, long before editing takes place.

Organising your idea

A good hand-print can express as much of an artist's intentions as a painting, but a mechanical print can only ever depict a process. Without seeing the contact print or RAW file starting point of many great photographic images, it's impossible to tell how long a journey they have made.

However, you can develop an awareness of good printing skills by looking at photographers' monographs and analysing the elements that contribute to the making of a good print. Also look at figurative painters, from the hackneyed Rembrandt to Goya and Manet. These artists pulled and pushed colour and tone around their paintings until a balance of light and shade was achieved. Look carefully at the way backgrounds are rendered too, and how the empty shapes and spaces enhance the primary subject.

Before starting on your hand-printing exercise, it's essential to have a plan, or you will drift in and out of countless variations. Start by deciding on the purpose of the print and identify the main subject to be celebrated. Next, make a mental list of the imperfections of your unprocessed file, marking the areas that are too dark, light or tonally flat. Then examine the colours in your file and identify any that dominate or recede. The editing of the image now relies on your judgement: brighter or darker, sharper or smoother, muted or vivid.

The Target project

The original image captured a very painterly sign that adorned a derelict aircraft hangar. It was shot in very flat lighting and the original file, shown below, did nothing to reveal the shape, texture or possibilities of the original scene. The final version, shown right, was made by using a wide variety of simple tools. They included the Sponge to raise the saturation of certain colours, burning-in using Selections to break up monotone areas and finally contast, applied by brush to raise some textures. The end-result now fulflls the original file's potential.

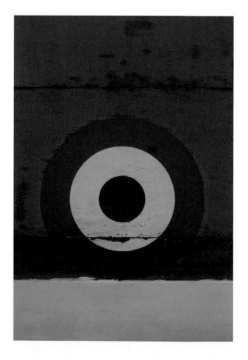

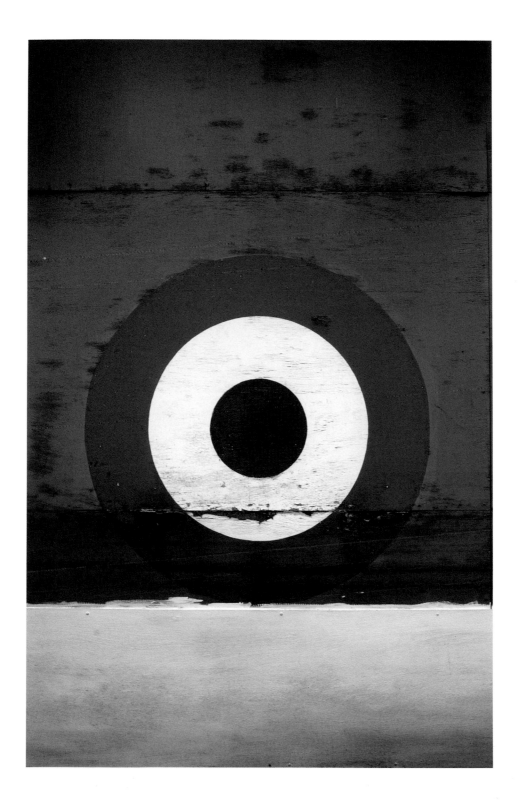

Graphic style

Described by geometric shapes, lines and compostional tricks, the graphic style can give much-needed order to mundane subjects.

Composition is the skill by which a photographer places subject matter into an ordered and visually appealing arrangement in the camera viewfinder. For immovable subjects or those essentially out of reach like a spectacular natural landscape, composition is entirely influenced by your own shooting position and choice of lens. For more pliable and accessible subjects like people, composition can also be determined by direction and organisational skills. No photographer was born with innate compositional design skills. Most are acquired along the way.

Graphic shapes
Compositional skills are hard-won and only gained through the experience of shooting different photographic situations under challenging circumstances. Like fitting together a jigsaw, photographic composition is based on the intersection of shapes and lines. When faced with a subject in your viewfinder, each different piece of the visual jigsaw will vie for attention. Busy and cluttered compositions result from too much emphasis in too many areas of the image, and lack a strong focus and a clear message. Saturated colours and detailed patterns can overwhelm the main subject, as can sharply textured backgrounds. Distracting elements can often be removed from your work by simply changing

viewpoint or lens. If you can't move these objects out of your frame, you can easily remove them with software cropping tools. Visual weight is the effect of a strong colour or tone pulling the viewer's eye in a particular direction and if used effectively, can act as a counterbalance to the central subject.

Symmetry and assymetry
An eye-catching but simple kind of balanced composition is a symmetrical one. Symmetrical photographs are those which have near-identical elements on either side of an imaginary vertical or horizontal fold and, as a consequence, have an eye-catching appeal. As a starting point, place the main elements of your composition in the centre of the frame until a balance is achieved along the vertical or horizontal axis. Architectural and landscape subjects work well with this kind of approach, but you may need to pull additional items into the frame to balance things out. These kind of images don't need to be mathematically equal and can look very artificial if made that way.

Less straightforward to describe due to their innate imperfection, are the kind of assymetrical images that are visually attractive due to their imbalance and total removal from everyday experience. Most of these kind of pictures are happy accidents rather than carefully composed shots and celebrate the art of composition.

Diagonals
A really effective strategy to use when faced with straight-on subjects or a restricted shooting position, is to create diagonal lines in your viewfinder. Tilt your camera until one side is higher than the other. Then try to find a line in your subject that can be forced to run from one corner of your viewfinder to the other. Diagonals are a provocative way of interpreting the world we normally see, which is predominantly constructed from straight vertical and horizontal lines. Software-corrected compositions are easy too, by using Photoshop's Image····›Rotate Canvas tool to recompose bland originals.

▲

A diagonal composition together with a very shallow depth of field transforms a mundane subject into an eye-catching graphic print.

▶

A simple symmetrical composition was used to capture the open space and dramatic light at this location.

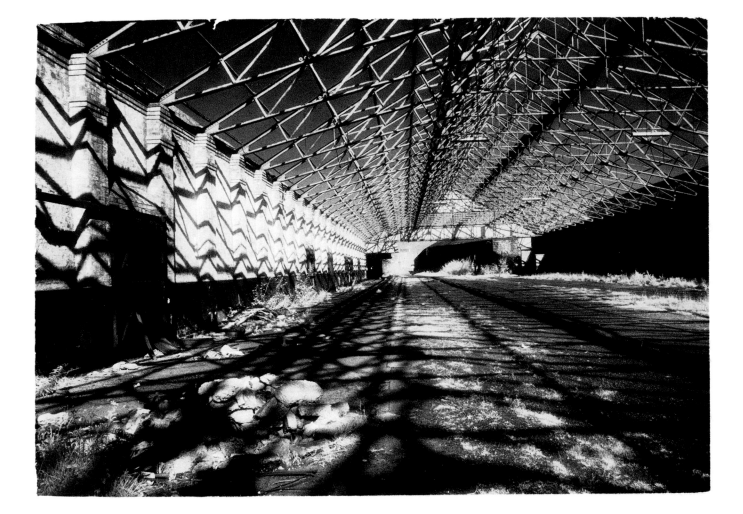

The print as object

Just like a painting or precious artifact, the digital photographic print can also be viewed as an object rather than a mere window on the world.

Developing the digital artifact

In the fast developing world of virtual spaces and photo-sharing, the actual physical nature of a photograph is in danger of becoming extinct. With many images existing onscreen only, in the virtual playgrounds of MySpace and Flickr, photographic printing has a real opportunity to stand out as a hard-won, hand-rendered skill.

Inkjet output provides many opportunities to print onto unusual media, such as the book shown above. Blank pages were detached from a vintage King Penguin hardback, printed on, then stitched back together to create an unusual mixture of fact and fiction.

Printing on ephemera and materials not normally designated for inkjet use can add an extra layer of meaning to your work. Perhaps the fabric of the print medium itself can contribute to the overall message or meaning, rather than acting as a simple support for your ink.

Vintage processes

Nowadays, there's much more interest in nineteenth-century photography and many photographers are looking to that period in search of inspiration. Many nineteenth-century processes were forms of complex craft-printmaking, where coatings, chemicals and substrate created unique one-off objects.

With this innate dependence on hand preparation, no two versions of the same original existed, especially in the direct positives of Louis Daguerre. The above example is a modern-day digital recreation of the salt print process, as invented by Fox-Talbot. The image is an inkjet print onto writing paper, with deckled edges and cream highlights.

Using antique papers

This example above is an inkjet print made onto a sheet of antique paper torn from a damaged book and was produced to mimic the look of a carbon-tissue print, like the work of photographer Josef Sudek. By using unconventional materials, your prints can take on a very different feel and evoke an unpredictable response from your viewers.

Printing onto unfamiliar media does have its challenges and can be time-comsuming. Yet, if you are prepared to scout around for possible materials, you could find papers that already have a kind of visible history, aged and marked by the passing of time.

This example shows how cream paper can be used to enhance the appearance of a period location.

Reportage style

Based on the principles laid down by Henri Cartier-Bresson, the reportage style adopts an ethical approach to photographic printing.

Ethical dimensions

Following the example of Henri Cartier-Bresson, no dedicated documentary photographer would ever consider cropping the original negative or digital file.

Bresson proclaimed that the very best photographers should be able to pre-visualise their final prints at the point of exposure. This would be no mean feat for the rest of humanity that followed in the footsteps of this great artist. Bresson meant that, like a painter, a photographer should be able to see the end-result before starting and use every ounce of skill and intuition in the shooting process to realise that goal.

In practice, this meant focusing on two key elements: composition and pressing the shutter at exactly the right time - the 'decisive moment', a phrase which will always be associated with Bresson.

Film photographers could easily crop their negatives during the printing process. They could redesign their attempts into stronger compositional arrangements and ignore this hard-won concept. For those who followed Bresson's principles, this would effectively be 'cheating'.

As evidence of his skills and the integrity of his printing, Bresson printed with a thin border around the negative edge, so we can see the exact edge of his frame, as he saw it in the camera viewfinder.

Rather than simply treating this edge as a decorative border around his images, the rough black line was created by the careful preparation of an enlarger's negative carrier. Using a fine metal rasp, the aperture of the carrier was slightly enlarged equally around all four edges, so the negative would be projected through in its entirety, together with a thin sliver of the original film rebate, transparent in reality but printing out black.

To viewers of Bresson's images, this thin black edge symbolised the integrity of his approach. The full frame conveyed his unwillingness to present a fabricated or altered version of events witnessed and is visible in his classic books of un-cropped, pre-visualised images. Of course, the shape of the books also needed to be a custom size, to accomodate the uncropped 24 x 36mm images.

Today, of course, the thin black edge remains very much in use by many film-based photographers for reasons of style and personal integrity. In the digital world, there's currently no such method of presenting an unedited image, unless somebody develops a visual way of showing printed RAW files that have not been manipulated.

However, the traditional effect is still possible to achieve, leaving aside the integrity issues, by adding scanned border shapes to the outside edge of your files, or filing out a scanner film-holder.

Rebate scanning

The example shown above was originally captured using medium-format film on a 6 x 4.5 camera system. The negative was then scanned using an Imacon film scanner at super-high resolution.

In addition to the quality of the sensor, these scanning devices also have slightly oversized film carriers which allow a small amount of the film rebate to be scanned at the same time. This provides exactly the same kind of edge effect and authenticity as a filed out negative-carrier.

For those willing to go a step further, an individual scanner film-holder can be modified to create your own 'signature edge'. Filing out or trimming off the edge of a plastic holder will create the same unique edge to your scans each time.

Stranger than fiction, a swordfish caught in the once-murky waters of the River Mersey in Liverpool, is displayed for the camera. ▶

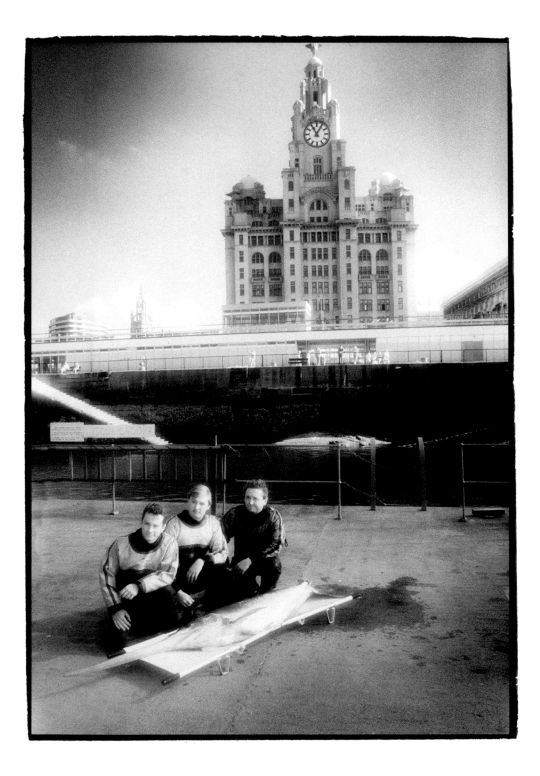

Chapter 2

RAW FILE PROCESSING

Capture-back data

High-performance capture-backs are available for most professional camera kits, so you can still use your old lenses and film stock on the same shoot.

Phase One digital backs

Ultra-high performance digital backs are made by Phase One, the established market-leader in this field. Capture-backs work by being clipped onto the body of a standard medium-format camera or large-format kit, just like a removable film-back, and provide a seamless transition to shooting digital files.

Capture-backs are currently expensive (at least five times the price of a professional medium-format camera kit) but are available to rent from many professional outfits. The Phase One series, shown below and right, offer backs in different shapes to match familiar formats such as 6 x 6 and 6 x 7.

Latest models can capture up to 30 megapixels of uninterpolated data, or 120 mb files, a gigantic amount of information and three times the capacity of a professional digital SLR. This size is more than enough to create high-resolution images for CMYK reproduction.

For studio photographers and locations where it's possible to shoot tethered to a desktop computer, most digital backs provide capture software to improve your workflow.

Essential for high-volume catalogue photography, capture software can process, label and reference work as it is produced, thereby saving later time-consuming editing.

File format options follow the standard TIFF and RAW variants, so work can be captured, archived and processed at maximum quality.

Since their introduction to the professional world, capture-backs have improved enormously, particularly in the area of exposure delay.

Formerly, capture-backs struggled to store high volumes of data fast enough to allow the next shot to take place. The latest models offer near-continuous shooting with little or no delay and now also offer very lengthy exposure times.

With the cost of film, couriers and professional processing adding a significant expense to a shoot, a digital back can be an economic tool to rent for a specific job such as catalogue photography, fashion or portraiture, where many exposures will be made to meet a demanding client's needs.

A good addition to the latest models is the facility for them to be used with long exposures. Earlier devices used to struggle to match the versatility of film when used in low-light conditions or with creatively long exposures.

Many photographers would still shoot on film in this instance, but the latest capture-backs have solved the problems caused by noise and consequent loss of image quality.

Capture-backs are still the only tool to use if you want to shoot and store true square-format digital images. Their costs may be out of the reach of most keen amateurs at present, but they are sure to become more affordable in the future.

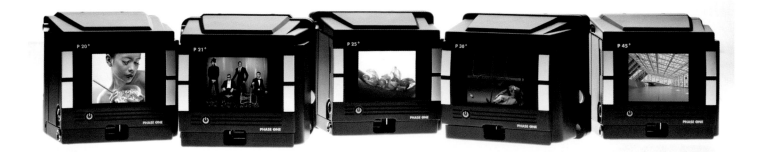

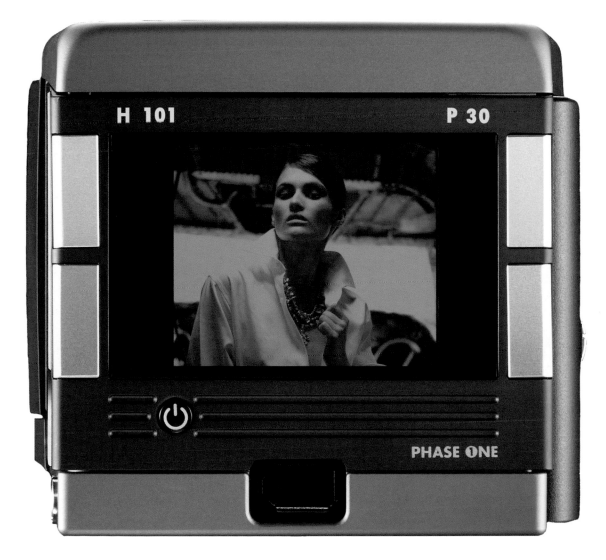

Scanner data

Professional film scanners provide high-resolution capture from a wide variety of conventional film types and formats.

Despite recent increases in digital camera resolution and affordability, many photographers continue to shoot on conventional medium-format film stock. Using a film scanner, very high-resolution files can be created from processed negatives or transparencies.

Scanner brands such as Hassleblad and Nikon are designed to accomodate film formats up to 5 x 4 and can create gigantic files in excess of 200mb. Each specialist scanner is supplied with capture software, which provides desktop controls for correcting exposure and colour imbalance at the point of capture, to create ready processed files suitable for enhancement in Photoshop.

Professional scanning devices such as those produced by Hasselblad, formerly known by the brand name of Imacon, are designed with speed in mind. They capture 100mb of data in little more than a minute and provide excellent results from colour negative, transparency and monochrome film. Like the RAW file format available in many digital cameras, certain scanners can capture and store images in proprietary file formats which can be saved and stored as an archive file.

For very large output or high-resolution printing, it's much better to start with a high quality scan of your film, rather than a high quality scan of a print, as much more detail will be revealed from the film. But despite the ability of many scanners to

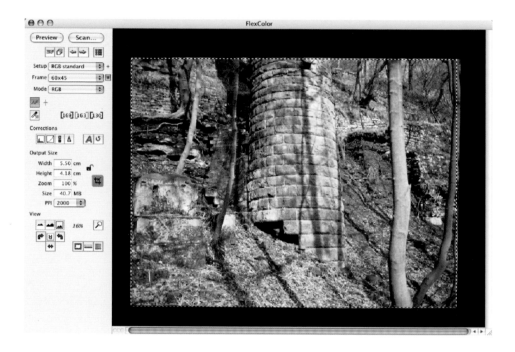

The sophisticated FlexColor software is used by to control capture in Hasselblad film scanners. ▲

Hasselblad professional film scanners provide high-speed data capture from all common formats including 5 x 4 sheet film. ▶

capture at ultra-high resolution values such as 6000 pixels per inch, it's important to remember that 35mm film can only be enlarged so far. It would be difficult to see any more detail in a 100mb scan than in a 60mb scan.

Accurate tonal and colour values are the key to effective scans, rather than relying purely on resolution. Better results are gained when capturing in 16-bit per colour channel mode.

Despite the current limitations of most hardware and software, which is restricted to displaying 24-bit images in a palette of 16.7 million colours, scans that are created using the 16-bit per colour channel capture mode will capture delicate colours and colour transitions without parallel. Files that are captured in 16-bit, then changed into 8-bit files for processing, display and output, will be better than original 8-bit scans.

Using the Camera Raw plug-in

A time-efficient method of processing RAW files is to use Adobe Photoshop's free Camera Raw plug-in and Adobe's Digital Negative Converter.

The best way to imagine the RAW file state of a digital image is to think of it as the latent image held on an unprocessed piece of film. When conventional chemical development takes place, the latent image is selectively amplified to reveal tonal values of your choosing, greater or lesser acutance, perhaps enhanced or minimised grain, or even subtle shifts in colour values. Once film is processed, however, there's no way to return to the latent values, but in the digital workflow there is.

RAW is a term that has long been around, but is now gaining momentum due to its increased support by Adobe Photoshop. This term does not imply a single universal file format, but a group of camera manufacturers' own variations on the same theme. All the major players offer camera-users the opportunity to shoot and store in their own RAW file formats, which all have non-standard file extensions such as Nikon's own .nef and Canon's .crw.

These subtly different but essentially similar RAW file formats can be categorised by the same properties. All offer unprecedented archival qualities, as the data stored in the file is the unadulterated data as presented to the image sensor at the moment of exposure. In addition to the pure image data as recorded by the sensor, RAW files also carry a component called metadata.

The metadata records useful information from your camera such as its unique type of colour filter array, the shutter speed used and white balance setting. The metadata records the characteristics of the shot and can be used later on as baseline instructions for processing your file.

Unlike other commonly used shooting formats such as TIFF's and JPEG's, the RAW formats are not processed to fit within a narrow set of standards, they can be processed by end-users in whatever way suits their own creative purposes.

To extend the film analogy further, shooting with the RAW format allows you to 'develop' a version of your image within Photoshop from a fully latent source, and go on to 'develop' further versions should you wish to do so. Above all, your RAW image-editor is unable to save any changes back into your RAW file format, so your original data is preserved, or archived, like a digital negative.

How RAW converters work

Each digital camera is equipped with a number of different software protocols that convert RAW file data into a file format of your choice. Once captured by the image sensor the RAW data is interpreted by the camera's own built-in

RAW file converter. As you would expect, the types and qualities of these converters are variable by manufacturer and the conversion process itself is also determined by the file format selected for storing the captured file. When in-camera processing is allowed to occur, such as when the JPEG file format is selected, the RAW file converter applies a film-like curve command to the RAW linear scale, converting it into a more pleasing effect.

Yet once this curve has been applied, there's no going back and it may well also stretch the tonal range so far as to severely limit future editing. This fundamental trade-off between image quality and convenience is one of the reasons why the RAW file workflow is gaining momentum.

By avoiding the embedding of unwanted in-camera processes in your images, you are maximising the future potential of your file.

As all Photoshop users will remember, only limited tonal editing is possible on a JPEG file before severe histogram banding takes place, but shooting with the RAW file format gives you unprecedented possibilities for making numerous sophisticated adjustments without over-processing. Best of all, you can return to your uncorrupted digital 'negative' at any stage in the future and re-interpret it into a brand new print.

Adobe Bridge

After shooting and storing your RAW files on your camera memory card, these must be processed first before they can be opened in Photoshop. There are a few different ways to proceed to this first step, but the easiest is to start with Adobe Bridge, shown right. Essentially an advanced file-browser with automated actions built in, you can use it to process multiple files and synchronise common characteristics. Ideal for those RAW file shoots where you could face a prolonged editing session repeating the same processing sequence on each file, Adobe Bridge is an ideal tool to use for commercial work. Bridge also offers you the option to view your RAW files and read their individual metadata. Within Bridge, you can view thumbnails of all your RAW files quickly and easily and have the opportunity to 'tag' them with preset RAW file processes. This 'tagging' does not become embedded within the file and can be removed at any time, so as not to compromise the archival qualities of your file.

Adobe DNG Converter

If your format is not supported by the Photoshop Camera Raw plug-in, another option is to use Adobe's free DNG converter, shown right. Designed to convert your proprietary file format into the universal DNG format, this will help you to create an archive file which will be always forwardly compatible. The Digital Negative format (.DNG) is based on the TIFF file format, as are many other RAW formats, and captures two components: the original sensor-level pixel brightness and a hidden component of your image file called metadata. In use, the DNG Converter acts like any other file format or compression utility, using a one-stop window to command all functions from input to output.

Apple Aperture

Aperture offers you many more tools and functions for working on RAW files without first converting the file into a more acceptable format such as TIFF.

Designed to offer only the core essentials that a photographer needs, unlike the industry-standard Photoshop, Apple Aperture also leaves aside the main graphics and repro tools. Apple loads RAW files into the main application straight away without any conversion, so there is no RAW file plug-in window with a limited selection of tools, as with Photoshop. Printing, preview and comparison are all possible and much easier.

Non-destructive image-editing

The most interesting aspect of the application is its raft of non-destructive editing functions that allow you to work without anxiety or concern for your original file. Built to work in a completely different manner to Photoshop and most other image-editing packages, Aperture creates versions of your files as you work on a project, leaving the original file write-protected, so you can't accidentally over-write it and press the Save button.

All the essential tools are available to solve the most common image issues, such as red-eye, noise reduction, dust removal and, of course, exposure. In contrast to other packages, with Aperture you only have to apply corrective editing on one version of the image. Your changes can be transposed to all other versions without any extra editing time using the innovative Lift and Stamp tool.

'Versioning' as a concept is beautifully effective and allows you to build or interpret your digital negative each time as a master printer would in a conventional darkroom. Like many lesser-known software products that have emerged over the years to challenge Photoshop, including plug-ins like Extensis Intellihance, Aperture offers you the chance to produce multiple, eye-catching versions of the same image with incremental changes applied.

Like checking a test strip that displays not just exposure changes but perhaps 50 degree variations in colour temperature, looking at multiple variations on screen side by side really does help to choose what's best. Usefully too, for those photographers who still think in stops or EV proportions, you can also display a range of variations built around the rise or fall in EV values. Just as Photoshop enables you to create duplicate documents from any History state, Aperture's advanced version allows you to step and compare a wide range of non-destructive edits, such as Levels, cropping and a variety of colour enhancements, until you create the look you want.

However, instead of lumbering your computer with the task of displaying ten or twenty versions of your favourite image on screen, Aperture is economic in its use of memory resources. Using an innovative method of linking versions to a master file, it dispenses with the need to create a full-resolution file for each variation, which clogs up memory and reduces processing speed; in fact, hardly any extra data is created at all.

Many of these functions are available in Apple's unique floating desktop palette called a Head Up Display, or HUD for short. A kind of hovering contextual menu, it offers the chance to edit your images using the full window area of your desktop without menu or toolbar clutter. For many users who prefer to use Photoshop in full-screen mode, concentrating purely on the visual elements of each composition, this alternative is a real must-have. Essential features of the HUD are the innovative Levels display which shows you the red, green and blue histograms displayed on top of each other, so you can see the effect of each edit on your file.

Compare and select tools

Editing, labelling and renaming all take time and the temptation is to never fully examine each image before you decide to change it. Aperture offers a range of tools to help project management, which are in some ways more intuitive than Photoshop's extended Browser functions. If you're happier with viewing more than a couple of images from your shoot at any one time, then the different viewing options really extend your creative freedom like no other package.

Called the Filmstrip option, each file is displayed in miniature but not so big that it dominates the desktop. For a larger display,

you can even arrange multiple files side by side, so you can simultaneously view perhaps eight different shots, all with their metadata shown underneath to aid your decision. Like a desktop contact sheet, this could help you (or your client who is sitting alongside) to make quick judgements about the direction of a shoot. Indeed, most major photographic anxieties are catered for with the innovative Loupe tool.

This is a much more versatile image magnifier that can be applied to one or more images simultaneously, so you can check the fine focus of the most important shot detail. The Loupe can even be pointed at the tiny thumbnails, so they enlarge immediately from the Filmstrip in a similar way to the pop-up functions of Apple's Mac OSX environment. The most extravagant manner of using the application must lie in the use of two monitor displays side by side. It is able to show versions of your project split between the two monitors. Providing you have the right hardware configuration (and the bank balance to afford it), you can view each final finished image in the context of its own shiny monitor.

The Light Table
Perhaps the most unusual but welcome addition to this application is the very 'left brain' Light Table. Taking as a starting point an old-fashioned lightbox, this additional viewing function allows you to pull images into Aperture from any source and arrange them side by side, or even in a cluttered, haphazard fashion to aid your decision-making. Once launched within the lightbox, each image can be dragged and arranged as you wish making editing a photo-story, feature or sequence of images that much easier.

Large volumes can be edited quickly and easily when they are side by side, just like

Apple Aperture provides a sleek, user-controlled interface where you can compare, edit and review work in progress.

35mm transparencies on a lightbox. Unlike many other display functions in other applications, your personalised Light Table arrangements can be saved, stored and even printed out for immediate despatch to your client's, or your own, satisfaction.

Printing and colour management
Able to accommodate input and output profiles to keep on top of image quality, Aperture works with ICC compliant profiles and uses ColorSync as the colour-management module for the task. All standard printer and print media profiles can be used and the application even allows you to create your own custom output profiles, for saving a favourite combination of settings and parameters when targeting a printer/ ink/ paper combination.

Like Photoshop, Aperture also allows you full soft-proofing tools so you can preview the likely results of printing-out on a target paper before you waste it. Soft-proofing depends entirely on your choice of the most up-to-date profile for your paper, which can be easily downloaded from most manufacturers' websites. To reverse out of a potentially poor print situation, Aperture offers standard Gamma and Black Point Compensation tools to rectify outcomes that are flatter than desired.

Technical requirements
At the time of writing, Aperture is available only for the highest specification Apple computers with specific processors. To check whether your system is suitable, visit www.apple.com

Adobe Photoshop Lightroom

Adobe Photoshop Lightroom is an application that offers an entirely new way to process RAW files into top quality print-ready outcomes.

Looking back at the development of image-editing applications over the last ten years, Lightroom is a combination of browser, cataloguing software and RAW file processor that allows you to organise and develop your images in a non-destructive manner. Unlike Photoshop, it doesn't provide masks, layering and other illustrative tools, but focuses on the nuts and bolts of straight image-processing for print and web use.

For professional photographers who use very little of Photoshopís gigantic functionality, Lightroom and Aperture offer faster and more targeted applications that really deliver. Unlike other image-editing packages, commands and changes made to an image in Lightroom do not become embedded in the actual source file, but are 'tagged' to it instead, leaving the original unaffected. This is known as non-destructive image-editing.

Starting and launching

Once launched, the application needs to be pointed to a collection of images, known as a Library, for it to work. You can easily point Lightroom to any existing folder of images on your hard drive or straight from your digital camera, via a simple File----⟩Import command. At this point, you also have the choice of duplicating your source images into a new folder or even converting them into the universal DNG format. The ability to re-organise and re-name your shoot, rather than continually guessing the identity of image files with the DCS_0003.jpg filename, is particularly useful. It's great if you want to divide a large shoot into different subjects and re-catalogue files with new names or in a different order. For those building up very large catalogues, you can also add your keywords here, in a universally recognised format, thereby making it easier to search and retrieve your files later on. The exact location of your new shoot folders is user-defined in the Preferences.

Library options

A significant benefit of Lightroom is the ability to arrange images into different groupings called a Shoot or Collection. If you've been used to physically arranging files and copies of files into different directories or folders in order to manage an effective image library, you'll really like these features. A Shoot is a collection of images drawn from one or more sources, as its name applies. A Collection is best thought of as a 'greatest hits' folder, images drawn from other shoot folders into a special compilation. Best of all, your files never move from their original location when incorporated into either of these two options. They are merely linked in, and there is only ever one file.

View functions

Lightroom is arranged in several desktop panels, all of which are easy to re-size, depending on your personal preferences. The application is divided into five separate function areas: Library, Develop, Slideshow, Print and Web. Each of these five modules is accessed through simple buttons at the top right of the window. In the Library editing mode, the default area on opening, the application presents you with browsing and importing controls, a variety of different thumbnail view options including the Aperture-like Filmstrip along the bottom of the monitor.

In Grid view, all your images are presented like a contact strip, so you can visually edit your shoot with ease. Poor shots can be deleted from the Library (but not your hard disk source) and image views can be rotated and even rated along a 1-to-5 star scale to help you tag favourable shots for later editing. There's also a quick link to launch your chosen file in Photoshop.

In the Loupe view, you can zoom into a specific area of a single image, (in much the same way as the Navigator works in Photoshop CS) to check fine focus.

The final View option is called Compare, where you can Shift + Click your way to viewing two or more images in the central desktop panel. This is really useful if you want to compare slightly different

variations in composition or exposure. Alongside all View options are quick reference panels, such as the combined Histogram showing different colour channels and a Quick Develop panel, should you just want to apply basic image edits.

The Develop module

Develop is the most interesting of all the modules, in which you can access the full range of controls to process your images in a non-destructive manner. On the right-hand side of the desktop is a fluid panel of controls, starting with the Basic collection of colour temperature, exposure and brightness/contrast options. At this point you can alter the colour temperature of the shot, either manually or by re-assigning one of the custom presets such as Tungsten for a more creative result. Exposure can be altered here too, albeit via a simple 0-100 slider, but this is best left to the Tone Curve in the next panel. Familiar to Photoshop users, the Tone Curve is a combination of Histogram sliders and Curves commands.

There are three areas that you can edit: highlight, midtone and shadow. They can be altered by typing directly in the text box or by pulling the compression slider to reduce and pushing the luminance slider to increase. As you push and pull, so the shape of the curve will alter to describe the new tonal position of your image. Unlike Photoshop's Levels and Curves, which are very much kept separate, they are very much combined together in Lightroom, so you can see how one influences the other.

Next is the intuitive Crop and Straighten module, which permits cropping to a

Adobe Photoshop Lightroom provides an easy- to-use Develop module, where you can access tone, colour and sharpness controls.

better composition and fixing wonky horizons. All commands made in this module are reversible, so a crop is not made forever, with cropped-out pixels remaining 'hidden' rather than actually discarded. Moving down the edit sequence, the next panel of commands is the Greyscale Mixer, which is much the same as Photoshop's Channel Mixer. Like switching on the Monochrome option, this dialog allows you to remix varying amounts of original colours before making a mono conversion. As with the Channel Mixer, the total quantities of red, yellow, green, cyan, blue and magenta look best if they all add up a set value, in this case 300.

Split-toning is the next dialog and offers a similar type of command to Photoshop's

Hue/Saturation dialog, albeit with both Highlights and Shadow options available within easy reach. Here, new colours can be added to the polar ends of an image to give the impression of a split-colour print toner effect.

HSL (or Hue, Saturation and Luminance) are the next set of tricks to edit your image and, like the previous controls, assimilate some of Photoshop's more familiar commands into a single dialog. They are all expert tools, easily available.

Next up are the Detail and Lens Corrections dialogs, aimed at sharpening and correcting lens aberrations and providing rudimentary 'burning-in' within a simple oval vignette shape. Sharpening is also available in the Print module, selected just before output.

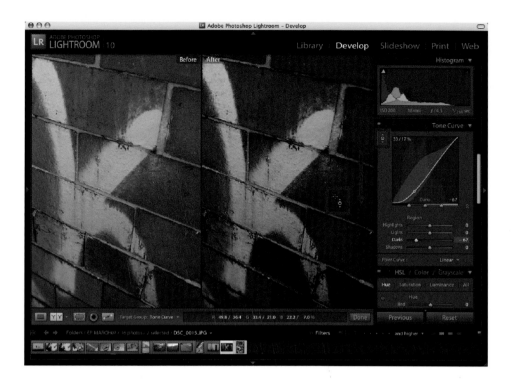

Saving and exporting

Once an image is edited to your liking, you can do one of two things. Remembering that Lightroom saves versions of edits rather than actual unique files, you can choose to export as a totally new file, or leave the edit embedded into the preview. With the latter option, the edit can be removed at any time, simply by pressing the Reset button in the Develop module. When exporting a finished version of the file, you can rename it, choose between TIFF, JPEG or DNG and pick from the usual compression options. Once exported, the image is ready to send to your client or chosen output device.

Presets

Lightroom is pre-packaged with several Presets, which apply a fixed amount of developing to an image. The few supplied with version 1 are somewhat disappointing, but you can very easily make your own.

At any stage of Developing, you can stop and save your sequence of editing as a Preset. It's a bit like saving a Photoshop History sequence and applying it like an Action. Lightroom is bundled with several Preset colour and tonal recipes such as Antique Greyscale, Cyanotype and the ubiquitous Sepia tone.

After you have generated a favourable combination of some or all of the Develop dialogs, you simply press Add Preset in the Presets dialog and you are prompted to name and choose which edit components to include. Your new Preset can be saved and will be stored in the Presets dialog ready to re-use. Unlike Photoshop Actions, Presets are easily edited when used on future projects.

The Targeted Adjustment tool

The first version of Lightroom contains a very welcome new desktop tone control, the Targeted Adjustment tool. Unlike a dialog panel slider, which provides greater or lesser adjustments while hovering over your desktop, this tool actually works within your image.

Start by clicking on the tool, as above, and then hover it over an area of the image that you want to tonally change. Click and drag the tool upwards to lighten the tone (and all instances of that tone in the image) or drag downwards to darken the tone. Simple and intuitive, it's the way all dialog boxes should operate in the future. As you drag it, your new tonal values appear instantly in the Histogram and Tone Curve graph, so you can see if you get too near clipping zones. The process is equivalent to moving your Levels without a dialog box in sight.

Using the F-stop scale

For experienced film photographers, a very useful control measured in f-stop values can be found within the Exposure slider. Unlike most digital dialog boxes, where adjustments are measured across an abstract 0-255 or 0-100 scale, the Exposure slider is calibrated in f-stops. Dragging the slider to +1.00 is equivalent to opening up one stop (or pushing one stop for E6 veterans). Dragging to -1.00 will have the opposite effect. These values also match the -/+ exposure compensation steps found on most digital SLRs, so you precisely edit any under-exposure or over-exposure with confidence.

The Exposure slider has an eight-stop range, more than enough for the most extreme errors of judgement and allows users to translate their previous understanding of image brightness and density into a digital workflow.

The Print module

For keen digital printers, the Print module really offers a sense of the finished article like no other program. The Print module is a much more intuitive method of engaging with a print preview and offers all the usual suspects for re-sizing, rotating and step repeating multiple print-outs.

It is provided, however, with a very useful Fine Art Mat template, which displays the print paper with cropping marks, a metal-type ruler and bleeds.

Unlike Photoshop's tiny Print Preview function, this is big, visual and really easy to use. Linked at the bottom of the dialog boxes are colour-management options for selecting the profile and rendering intent, plus the print (image size) resolution. In the Overlay options, all the familiar tools are present, including captions, border and crop marks and the Identity Plate graphic that adds your signature to your work. Ideal for printing your name and copyright notice over a sheet of proofs, the identity plate feature is an ideal way to embed details of a print edition such as media, ink, date and version.

Adobe Photoshop Lightroom's Targeted Adjustment tool offers an ideal way to darken down skies without the need for selections. ▶

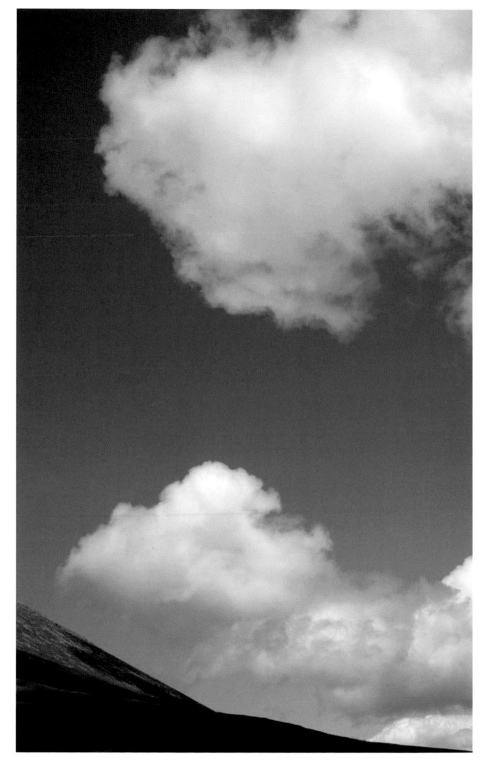

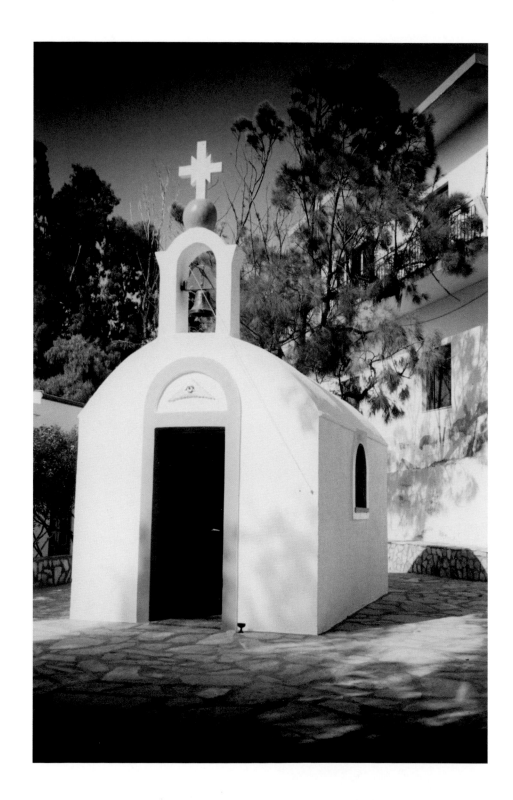

Chapter 3
CREATING EMPHASIS IN RAW EDITORS

Changing tonal emphasis

Lightroom offers a range of tools to manipulate tone and contrast within your RAW files and, best of all, the intuitive new Tone Curve controls.

Deep inside the interface, are two very welcome features for controlling contrast. At the top of the Develop module, the Histogram graph which is historically used to show you where the data stops and starts can itself be manipulated.

Unlike Photoshop's separate Levels and Histogram dialogs, this new version in Lightroom promises extra convenience.

To manipulate your image by direct use of the Histogram, open an image in the Develop module. Now, place your cursor inside the Histogram and notice that there are now four 'regions' that you can manipulate. These 'regions' correspond to the four sliders in the main dialog: Exposure, Recovery, Fill Light, Blacks. To manipulate any one of these, click into the Histogram and then move either left or right with your mouse, or use the Arrow Up/Down keys. Watch how your image now changes in the main window and you can control the quantity of change through a touchy-feely hand movement.

The second and arguably more adventurous fine-tuning change is presented in the Tone Curve dialog. Now equipped with four regions and three tonal bands and the ability to directly manipulate the curve. Most useful is the simplified manner in which data is presented here, gone is the 0-255 scale, which is replaced with an easier to understand 0 to 100 and 0 to -100 scale.

Lurking underneath is a simplified Histogram shape, so you see the relationship between the two.

The Tone Curve itself provides real value too; when a cursor is placed over the line, a faint grey shape appears, showing you the boundaries of the edit at both -100 and 100. Unlike Photoshop's Curves controls, where it was always possible to pull or push the Curve into a unusable shape, Lightroom's Tone Curve visually defines the outer limits for you.

For those unused to moving curves, these useful grey boundaries are greatly reassuring and the single, restricted point of manipulation is much easier than watching Photoshop's over-elastic version bend horribly out of shape in a completely different area. In addition to this intuitive manipulation of the curve, Lightroom offers an advanced method of pinpointing your edit to a single tonal area of the image.

The Tone Curve in Lightroom works in a similar way to Control-Clicking a specific manipulation point in Photoshop Curves. Open your image in the Develop module and with the Tone Curve dialog open, float your cursor over the image and let go of your mouse.

Keep an eye on the Tone Curve dialog, then make your desired manipulation using the Arrow Up/Down keys on your keyboard.

Quick Develop

Found in the Library module of Lightroom, the Quick Develop panel gives you access to limited contrast and colour controls. Like an Auto Levels or Auto Curves command in Photoshop, the Auto Tone button can give variable results as shown above. The top illustration shows the unprocessed starting point and bottom shows the same image after an Auto Tone correction was applied. In this instance, the command stripped all atmosphere away from the original image.

Using the preset Point Curve

Lightroom comes equipped with three preset curves shapes, so you can apply a range of different contrast effects to your RAW file. These presets can be very useful to apply to batch of images, to create an overall uniform look, but much more control can be had by dragging the Tone Curve shape by hand.

This example, right, shows the before and after states of a work in progress image. Although there was strong contrast already created by natural light, a Strong Contrast preset was applied, shown by the right hand version of the images.

Notice how the colours have become richer and the black shadows darker. Note also the final shape of the curve, a gradual sloping 'S' shape.

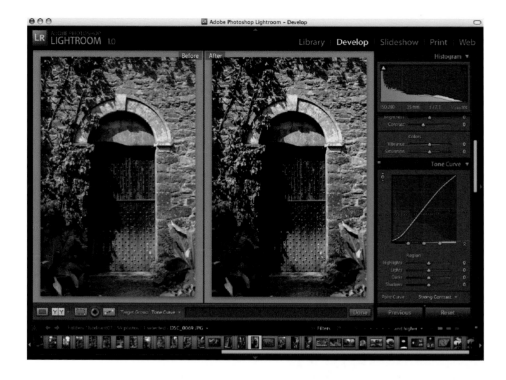

Using the Tone Curve manually

Much better results are gained if the actual curve is manipulated by hand. This example, right, shows the before and after states using the Tone Curve pulled into a custom shape.

The overall effect looks more punchy than the automated setting and this can be tailored further to match your printing media or inkset.

Tone Curve controls can also be embedded within Lightroom's saved recipe feature called Presets. This useful function can be used to match multiple images up together, so creating a synchronised set of images for print or web display.

For the results of a shoot under very specific lighting conditions, this function can enable you to apply the same amount of correction to a number of different images, thereby saving the effort involved in working on each file in turn.

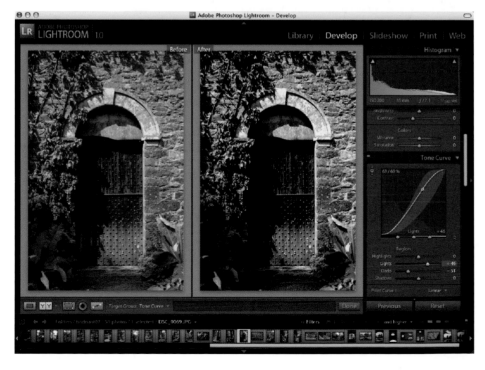

Changing colour

RAW editors provide an opportunity to change the colour temperature of an original file, plus a host of other mixing possibilities.

A prime example of the advantages of shooting in RAW is the ability to assign colour temperature values after returning home from the shoot. For fellow ancient professionals raised on unforgiving colour transparencies, this is as close as we will ever get to an unexpected lottery win.

Much can be edited in the White Balance dialog in Lightroom, even the ability to set colour temperature using the familiar Kelvin scale. Hidden under a tiny pop-up menu are several standard colour temperature settings, which can be used to mimic the appearance of shooting conventional tungsten film stock under natural daylight conditions, or other traditional process-derived styles.

The next step is to base a creative edit on a colour temperature change as a starting point, then apply additional colour edits on top. With Lightroom, you can collect a sequence of edits and then save your end results as a Preset.

This process is a more versatile way of saving a collection of Photoshop settings, ordinarily managed through an unwieldy self-recorded Action, for playing back over subsequent images. Lightroom Presets remain on the desktop dialog and record every modification you make in the Develop module, while offering you the chance to deselect edits that are perhaps too specific to your current work-in-progress to be applied to all future projects.

This example image, shown above, is an unprocessed RAW file shot in daylight. In Lightroom, a tungsten colour temperature was applied to create a colder, but more interesting result.

Colour recipe presets ⋯⋗

This example was created by mixing a custom colour temperature with some extra Tints and Tone Curve adjustments. As the Develop dialogs are presented as a coherent, single set of tools, it's simple to create unusual combinations that would not immediately seem obvious in Photoshop.

Presets are stored on the desktop and can be modified at any stage in the future by deselecting any component of the recipe to remove its influence. Presets are an excellent tool for printing a set of images in the same style.

RAW *greyscale conversion*

For discerning digital photographers, Adobe Photoshop Lightroom offers sophisticated controls and tools for monochrome conversion, without the risk of over-processing.

For many photographers, the relatively simple task of producing a greyscale version of an original colour image can be fraught and very frustrating. Most opt to avoid the simple Mode change or the not very intuitive Channel Mixer. Both processes remove the hands-on approach that is possible in Lightroom because of its easy interface design.

In the early days of digital, many photographers developed elaborate editing sequences to force the image around Photoshop, when no clear route existed. Techniques such as switching back and forth to LAB mode and dropping some colour channels were established. They enabled photographers to get the kind of results they desired when no straightforward sequence existed and helped to minimise the consquences of over-processing.

However, to make sensitive monochrome conversions, Lightroom offers a brand new method of greyscale conversion that improves on one of the most popular processing tools in Photoshop. Unlike the Channel Mixer, Lightroom's Grayscale Mixer provides an eight-colour control panel, so you can push and pull the original colour values until you achieve the desired effect.

Start by switching your image from Colour to Grayscale in the Basic panel found at the top of the Develop module (the Greyscale Mixer remains hidden unless you do this first).

Taking the colour image as a starting point, the green values are increased by moving the Green slider to the right. This brightens the tones in the grass and tree areas to avoid a dull, muddy result.

The effects take place on the fly, so you can see the results of your edit immediately and very little collateral damage occurs.

Of course, a colour image never looks the same when forced into a greyscale space, when relative brightness and saturation levels disappear, leaving dull and undistinguished tones.

Lightroom's control panel allows you to re-establish contrast and difference by lightening up or darkening down individual colours. Like the Tone Curve tool, the Grayscale Mixer also has a targeted adjustment tool. You can simply click and drag in the image to darken or lighten your chosen tone. Greyscale conversion forms the basis of this next course of action, one that is especially useful with images which have an over-dominant or distracting colour.

In this example image, below, a large blue door on the right-hand side provided sufficient

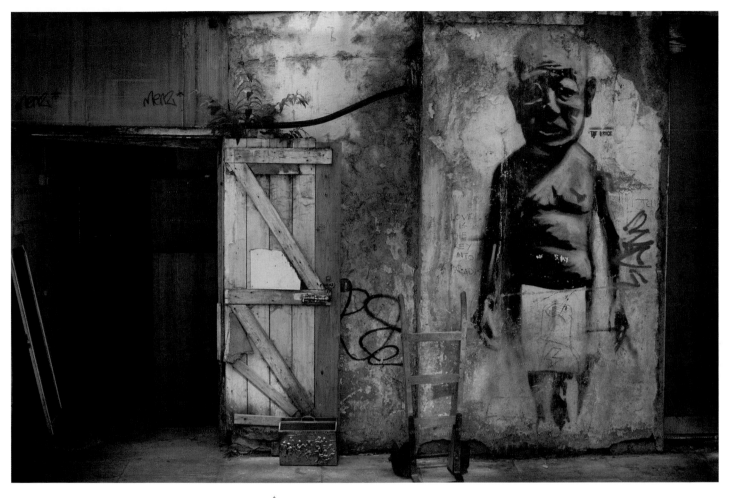

The final image is transformed into a tonally rich print, correcting all the imbalances seen in the original file. ▲

distraction to merit a sensitive removal.

Although conceived originally as a colour image, little (if any) colour impacted on the overall image, so a decision was taken to convert into monotone to improve the overall emphasis. After checking the Grayscale Conversion box, the blue tone was minimised by decreasing the value. Once this was corrected, the next step was to use the Split Toning dialog box immediately below. The Split Toning

controls offer a much simplified method of adding different amounts of different colours into two separate tonal areas: highlights and shadows. In contrast to the clumsy full-version Photoshop method of doing this via two mode changes, then colouring independently by tonal sector in the Color Balance dialog, the Split Tone dialog offers a much more straightforward way.

Choose a base colour to add to the shadow areas by moving the rainbow Hue slider to the colour of your choice. Next,

move the shadow Saturation slider to the right to choose the intensity of your colour. Opt for a muted shadow value combined with a brighter and more colourful colour, applied as a highlight. For darkroom users, this method offers a good way of mimicking chemical toners.

The advantage of editing in a RAW processing application like Lightroom is that you can never overwrite your original file, so you can return and re-interpret it at your leisure.

Vignetting

The simplest way to focus attention on a central subject is to create a vignette using Lightroom's Lens Correction tools.

There are some software tools that have become much more significant than originally intended. One example is the Lens Correction dialog in Adobe Photoshop Lightroom. Originally designed to counterbalance the shaded vignetting caused by ill-fitting lens hoods or over-use of screw-on filters, this control can actually be used to introduce a primitive kind of burning-in, with surprisingly good results.

Lens vignetting has been the scourge of professional photographers for many years. It's often not visible in the viewfinder, but all-too evident in negative and transparency film once processed. For many shots, the vignette completely ruined the composition, or worse still, the entire shoot.

Darkening the edges of an image to create emphasis on a central subject is a technique as old as photography itself and can nowadays give a vintage feel to your print, or even a mysteriousness that would be missing from a mechanical or straightforward print.

In the first release of Lightroom, there is no specific tool or function for applying burning-in or holding back to a specific area of an image, as there is in Photoshop. However, Lightroom's Lens Correction function offers a useful alternative for creating emphasis effects in your work, without using selections, masks or any other time-consuming and highly complex processes.

Starting off

Open your image and view it in the Develop module. Correct the exposure and colour first and complete any other editing before you make the vignette. This process should be the penultimate stage in your editing, with the Unsharp Mask filter as the final enhancement before exporting the file. At the base of the application window, select the Before and After viewing mode, as this allows you to more accurately judge the extent of your editing, as shown above.

Using the Lens Correction dialog

There are two sliders which can be used for applying a feathered darkening fringe to your image edges: the Lens Vignetting Amount and Midpoint sliders.

The Amount slider determines the darkness of the burning-in, with the Midpoint slider controlling the range or extent of the vignette across the image surface. Drag both sliders until you have achieved the desired shape. The final print, opposite, creates a much more evocative mood.

Chapter 4

DRAWING OUT DETAIL

---> Fixing print brightness

---> Fixing colour casts

---> Fixing print contrast

---> HDR processing

---> Planning your print

---> Initial print exposure

---> Shading quantities

Fixing print brightness

All digital files need careful processing before preparing for print-out and brightness is always the first stage of your editing journey.

Expose on the highlights and print on the shadows is an oft-repeated phrase in the practise of photography. In essence this provides the two golden rules for first capture, then later print-out.

Out on location, it's essential to record as much detail in bright highlights as you can without compromising the amount of visible detail in the shadow areas. This fundamental compromise has dogged photography since its invention.

Once recorded, the amount of image detail is fixed for ever and can't be rescued if it wasn't there in the first place. Slight exposure errors are very easily fixed in Photoshop by using the Levels dialog to remap the captured tonal range. As the following images illustrate, only slight modifications are required to clean up a dark or light original file and make it ready for printing.

However, stretching the tonal range in a non-RAW file does have its limitations. Extreme exposure errors can't be improved but the actual stretching of the range will prevent much more hand-editing.

Once stretched, the tonal range will start to break up and become posterised, that is divided into narrow tones or colours that become separated, like the flat colours on a silkscreen poster. Get your exposure right first time, or your creative hand-editing will be severely curtailed.

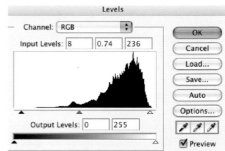

Correcting under-exposure

The top image is too dark, shown by the histogram shape leaning over to the left, or the shadow end of the scale. To fix, move the Grey midtone slider to the right until the image brightens, as shown.

Correcting over-exposure

The top image is too light, shown by the histogram leaning to the right, highlight, end of the scale. To fix, move the Grey midtone slider to the left until the image darkens, as shown.

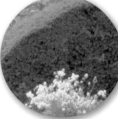

The above illustration shows how image detail reproduces differently under a range of print brightness editing.

Fixing colour casts

All RAW digital files can be improved by a colour-balancing edit to produce more vivid and accurate values.

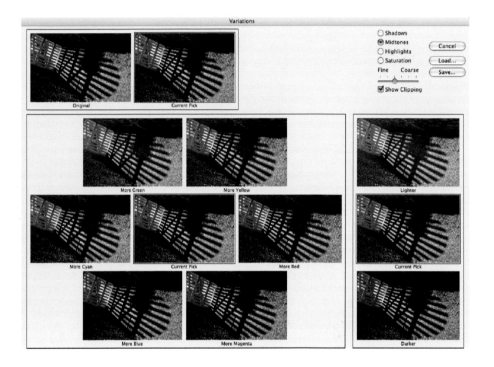

How they are caused

Delicate colour casts, usually caused by the irregular colour temperature of natural daylight, are very easy to remove. If you can visualise a thin coloured filter or lighting gel lying over your image, you can imagine that, once removed, all underlying detail and brightness will be restored.

More significant colour casts are likely to be caused by incorrect white-balance settings on your camera. These casts are best resolved in the colour temperature controls in an application such as Adobe Photoshop Lightroom.

Where to spot them

You'll never see a delicate colour cast in a highlight, shadow or saturated colour area, as it won't be visible. Instead, look for casts in neutral-coloured areas, preferably with a midtone value. The ease of spotting in these areas is demonstrated in the screen grab of the Variations dialog box, shown above. Notice the different colours in the normally grey paved area.

If you find it difficult to decide whether a cast is blue or cyan, magenta or red, then print out an equivalent version of the Variations dialog, above, and use this as a reference to hold alongside your proof print.

Using opposites to correct

In all digital image-processing, colour is managed by three odd couples: red and cyan, yellow and blue, magenta and green. When a colour imbalance is detected in your image, it is the other half of the couple that is used to cancel it out.

Magically, colour casts are removed by this process, leaving all underlying detail intact. It can be as dramatic as taking off a pair of sunglasses. Colour balancing won't alter the brightness of your image and should ideally be applied after your Levels or Exposure editing. What it does do, however, is raise the intensity of colours that have been lying dormant in your image due to an overall translucent colour cast.

To correct a blue cast, perhaps caused by shooting in the early morning, increase the Yellow value in the Color Balance dialog, as shown above. This will warm up the image overall and remove the cast. For an indication of quantities and their overall impact on an edit, see the pairings of red/cyan, green/ magenta and yellow/blue on the following three pages.

+40 +30 +20 +10 0 +10 +20 +30 +40

+40 +30 +20 +10 0 +10 +20 +30 +40

+40 +30 +20 +10 0 +10 +20 +30 +40

Fixing print contrast

Compression caused by saving in the JPEG file format can cause low-contrast originals, but these are easily fixed using the Curves controls.

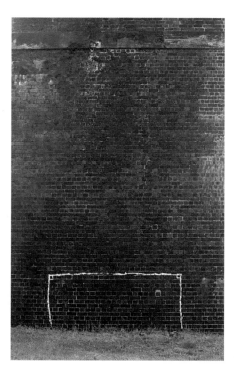

Starting point

This original was captured on the underside of a gigantic railway arch, where any hint of the gritty-atmospheric surroundings was removed by the capture process. Shot and saved as a high quality JPEG, the unprocessed file, as shown above, looks dismal and almost fogged, with no rich shadows.

The purpose of the following edit is put back some of the original lighting quality and to draw out the lost texture of the brick wall, making the final print as interesting as the subject.

Setting the curve

An S-shaped curve is a classic method for rescuing flat-contrast images and works every time with both monochrome and colour originals.

Open your Curves dialog and ensure that the shadows are set to the bottom left-hand corner of the graph, as described by the vertical and horizontal tonal bands meeting in the bottom left-hand corner.

If not, click on the tiny white/black triangle icon, circled above as red, to reset the scale in the correct place.

Next, click a marker dot on the very middle of the diagonal Curves line and two other marker dots, as shown above as big red dots. These markers effectively determine which tones you will alter in the next step. The centre of the three is the midtone, top right is near-highlight and bottom left is near-shadow.

Manipulating the curve

To create the S-shape, it's not necessary to move the centre marker dot, as this acts as an anchor, to stop the line from moving during the following two steps.

First click on the near-highlight marker dot in the upper right-hand quarter and move this gradually upwards, as shown. This will cause the highlight areas of the image to become brighter.

Next, click on the near-shadow marker dot in the bottom left-hand quarter of the dialog box and move this slowly downwards, as shown above. This edit causes the darkest tones in the image to get darker, thereby creating a little more punch.

The more extreme the slope of the S-shape, the more contrast is created; flatter, italic-like S-shapes create less contrast. The final result, opposite, regained both texture and atmosphere after toning.

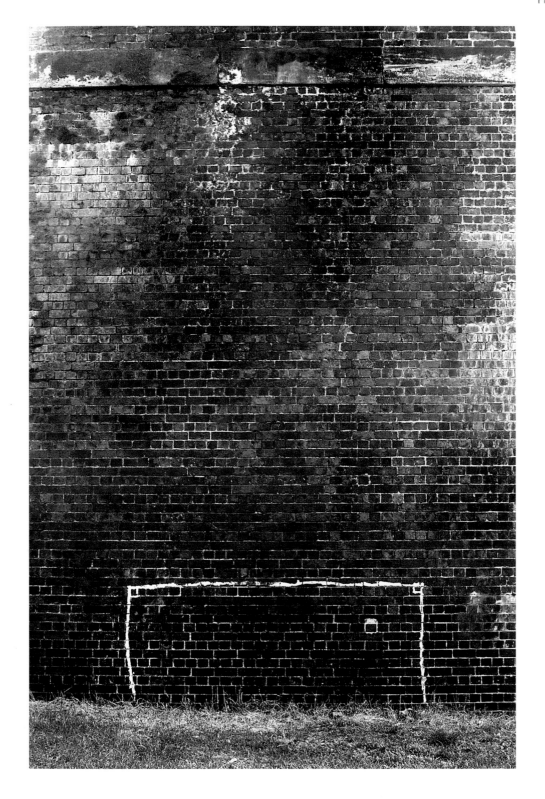

HDR *processing*

High dynamic range processing is the latest technique for extracting the perfect tones from several different files. For landscape photographers, this will revolutionise the way you shoot for ever.

The techniques of HDR have been a closely guarded secret for those in the know for a little while now. High dynamic range processing offers the photographer a hands-on technique for mixing the perfect tonal blend across shadows, highlights and midtone areas and all without the use of Selections, Masks or Layers. In fact, there's even no need to use Levels or Curves to organise the image ready for printing.

Very rarely does perfect lighting exist on location and on the occasions when your camera exposure captures the details in a bright sky, but not in the darker landscape, HDR processing can be used to get the best out this situation.

Although Adobe Photoshop offers an HDR processing function through its Automated actions menu, much better results are obtained when using a specialist software application like PhotoMatrix Pro.

PhotoMatrix Pro (shown right) works by mixing and merging together individual files which have been exposed under different conditions in a shooting technique called bracketing.

Instead of hoping to capture all tones and detail within one single file, three or more different files are created at the scene, each exposed differently to get the best out of highlight, midtone and shadow areas. These are then combined together into one perfectly balanced file for output.

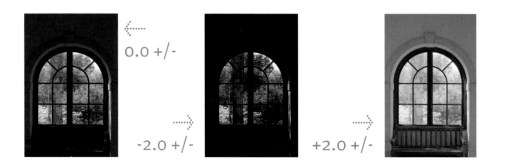

0.0 +/-

-2.0 +/-

+2.0 +/-

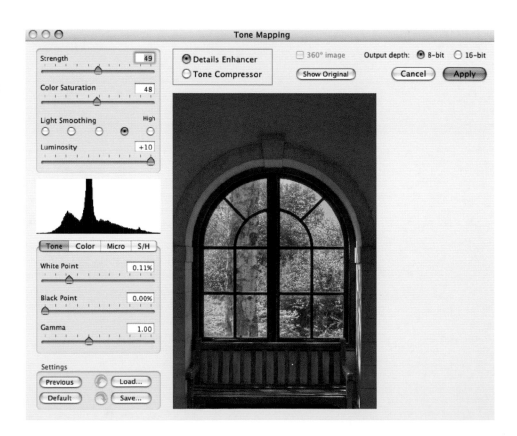

Shooting for HDR

PhotoMatrix Pro recommends that you shoot at least three individual files for later combining and suggests that they are bracketed as follows: one at normal 0.0 exposure value; one at -2.0 exposure value and one at +2.0 exposure value. When shooting on location, these exact bracketing differences are best set on your camera's +/- EV dial. Within this range, all possible tones are captured as the example on the left illustrates. The only drawback to using this technique on location is that you need to have your camera tethered on a sturdy tripod between brackets, as any change of position will result in ghosting or mis-registration when the three images are combined in PhotoMarix Pro.

An alternative to this method is to extract two extra 'exposures' from an existing file by using Photoshop's Image⟶Adjustments⟶Exposure function. This tool allows you to set the same rate of change on the universal +/- exposure value scale, rather than the 0-255 digital scale. This final result, shown right, was generated from a single original file which was processed with Photoshop's Exposure tool to create three different versions.

These three were then combined in PhotoMatrix Pro to create a single image which merges together the best bits of all three, without any obvious edges, noise or posterisation. Like the perfect amount of fill-flash, HDR processing can offer you the chance to retrospectively reclaim detail in shadow areas that would be tricky to manipulate without masking.

Weblink

To learn more about this application visit: www.hdrsoft.com

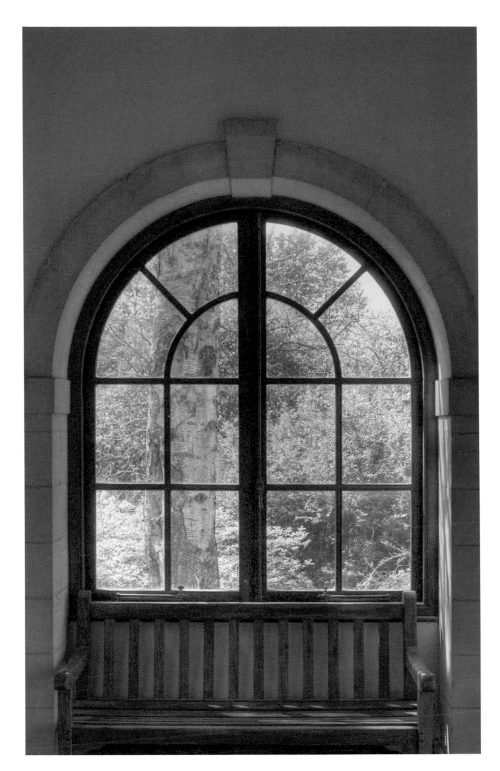

Planning your print

Fail to prepare and prepare to fail: ensure you have a printing plan before embarking on hand-editing, or you will allow the software itself to control your creative decision-making.

Deciding on your print style

Now that the initial tidal wave of software trickery that preceded the release of top quality digital cameras has receded, many photographers use Photoshop and other image-editing programs purely as a printing tool.

After all, if there's no good reason to filter your work, or apply radical colour changes, then don't do it! Printing styles and techniques are there purely to enhance and communicate your vision as a photographer to your audience. They are not an end in themselves, or even a reason to shoot.

For the very best photographers, the quality of their printing and the processes used are inextricably linked with the messages and meanings conveyed by their imagery. Your task as a photographer is to find an output style that matches your creative intentions. Get it right and your work becomes glorious; get it wrong and your work looks like a technical exercise. Emphasis techniques, as described in this book, are presented as possible means of helping deliver your own individual vision, but for real inspiration check out the work of other contemporary photographers in the flesh.

Examine real prints on the gallery wall rather than reproductions found in books and you will see how flat two-dimensional photographs are transformed by skilful master craftsmen.

Reflect on your starting point

The primary purpose of shooting this image was to play around with the shapes created by the target and the back end of a green bus. Although the RAW file didn't look too bland, there were several elements of the shot that I wanted to change through careful hand-editing.

The first change was to remove the unwanted box in the bottom left-hand corner, by burning rather than the more extreme task of cloning it out. Second, I made a rough plan to show which areas needed darkening. The trick was to ensure that the feathering of the Selection shapes in the original image suggested overhanging shapes rather than subtle burning-in.

The image was shot at a low angle and I wanted to emphasise the feeling of shooting through undergrowth and seeing the target in a confined space. The gradual shading around the edges was introduced to try to evoke this as it added a bit of mystery to an otherwise straightforward shot.

Draw up a simple plan

The plan was drawn up on a simple piece of paper, but this could easily be superimposed on a lightened print-out of your file.

Draw out the shape edges that you want to change and then plot the alterations. When planning your edits, try to think in terms of percentage points on your 0-255 scale (see page 64 for reference values) and annotate the areas you want to change with an approximate value.

Your plan can involve changing all aspects of your original file, including contrast, brightness, shading and colour saturation. For this project, both strong blue and red shapes were designated for enhancement using the Sponge tool, set to Saturate mode. Using this tool, I was able to add a little vivid colour to each of these shapes, to break up the flat tones and add a bit of visual interest.

The finished print, right, displays all the best bits of the image to their maximum potential, while marginalising all the elements that detract.

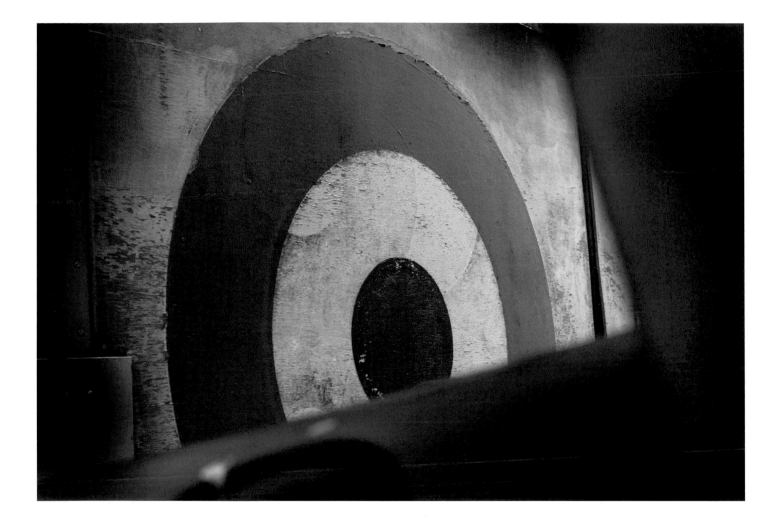

Initial print exposure

Preparing your image file without due consideration for future creative processing is a common mistake. The results will always look over-cooked.

Pre-visualising the likely end-result of an editing sequence comes only with experience and lots of practice, but is a most crucial skill to build for the creative printer. There is no fixed rule on the optimum brightness of a print, but output devices and media will limit the amount of detail and colour that can be seen in an over-processed file.

If your project file is likely to need careful hand-editing and darkening, then you will need to prepare the starting point in a different way than you would do when making a straight print. With an unknown amount of darkening to follow, it is advisable to lighten the Levels Input mid-tone value to 1.30. This additional brightening will look insipid when first applied, but will allow for the gradual seepage of extra exposure from feathered selections and soft-edged Burn tool brushes that will follow. This starting point would not be good for making an immediate print-out, but will allow the careful build up of hand-editing.

In setting your starting point lighter than normal, you are also allowing yourself to create additional contrast and drama where none existed. Start by examining your file and decide which elements need to remain bright during the editing sequence. Push the Levels until you can still see detail in the highlights and ignore any temporary loss of full black shadow values, as these can be put back.

Starting point

The unedited file, shown above, was initially muddy with a slight green cast which would have become more noticeable. The white flowers were the main subject of the shot, so everything else was lightened up.

Lightening the midtone

To create the bright starting point, drag the grey midtone slider to the left, as shown above, until the text box reads 1.30. The result will look insipid, (shown below) but will allow subtle finishing, as shown opposite.

Shading quantities

Setting and applying the correct amount of shading can be the difference between a skillful edit and a clumsy one.

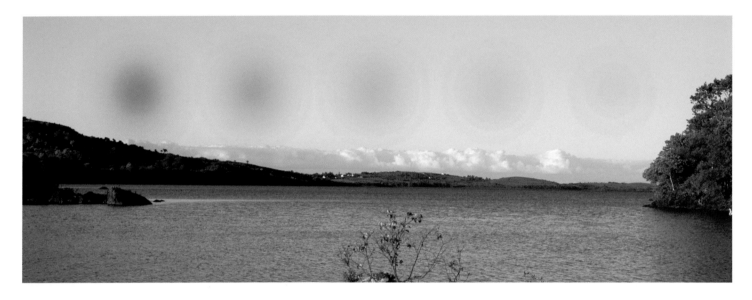

Using the Burning-in tool

The traditional method of passing extra exposure onto light-sensitive photographic paper was to shine the enlarger light through a crude hole cut into an even cruder piece of cardboard. The effect, however, was far from clumsy, allowing precise amounts of extra light to darken down specific parts of the print.

A similar effect can be created by using Photoshop's Burn tool, although the use of this tool needs care and caution.

The tool's properties include a simple Exposure slider which creates a more or less visible appearance and a drop-down menu which affords the choice of Shadow, Midtone and Highlight tonal sectors to target.

Brush shapes and hardness

All brush-based editing benefits from the extensive controls available for size, shape and hardness. Convincing burning-in is best undertaken with a large soft-edged brush, set with zero hardness and spacing values.

Depending on the size of the area you want to burn, set your brush size to fit easily within your chosen area, so you can overlap several separate instances of the tool. Your brush would be set too small if your burning-in started to become visible as unconnected darker dots. As with all Photoshop painting tools, ensure you have your History palette visible and set to record 50 states, so you can reverse out of an edit if it starts to look disappointing.

Burning-in results

In the test example shown above, the Burn brush was applied to five different areas of the sky, but used each time with a different Exposure value.

From the top left, the Exposure values were set at 100, 80, 60, 40 and 20 respectively. The brush was repeatedly clicked in the same area five times, to mimic a typical editing sequence.

Judging from the results shown above, editing with exposure values of 100, 80 and 60 would not be suitable, as the rate of change is too great and the edits become clearly visible. However, 40 and 20 would build up slowly but more convincingly. It's much better to make changes in lots of very small steps.

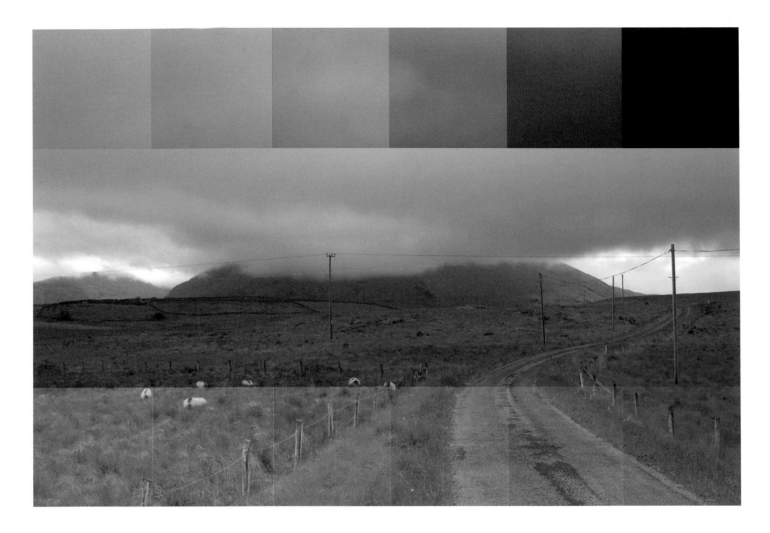

Using the Levels midtone slider

In the example shown above, each section of the image was edited with an increasing amount of Levels midtone adjustment. For different parts of an image it can be difficult to pre-judge the exact quantity needed, as this is relative to the lightness of the area you want to change. Areas that are midtone at first can be darkened easily, as shown in the sky area. A typical edit using the Burn tool could see it used 50 or 60 times to prevent it looking obvious.

Darkening down results

Each separate selected square in the sky area was given an extra 15 steps on the 0-255 Input Levels scale. On an unedited image, the starting point for the midtone value is 1.00. Starting on the far left with a value of 0.85, the sequence runs to the left as follows: 0.70, 0.55, 0.40, and 0.25 ending with 0.10. With the sky tone being a near midtone to start with, all except the final 0.10 value look plausible values for burning-in.

Lightening up

On the bottom edge of the sample image, shown above, is another set of six different tonal variations to test the effects of lightening up. Starting bottom left on 1.15, the sequence runs 1.30, 1.45, 1.60, 1.75 and finally 1.90. Compared to the darkening down scale, this is much less convincing, with only 1.15 and 1.30 variations appearing realistic end-edit points. Like photographic dodging, only minor changes can be made before excessive lightness looks contrived.

Chapter 5

DECONSTRUCTION AND DESTRUCTION

····⟩ Feathered adjustment layers

····⟩ Correcting colour burn

····⟩ Contrast on a brush

····⟩ Breaking up flat tonal areas

····⟩ Creating an illusion of 3D space

····⟩ Enhancing lines and edges

····⟩ Maximising saturation

Feathered adjustment layers

Gradual and seamless burning-in is simpler to achieve with the use of feathered selections and adjustment layers.

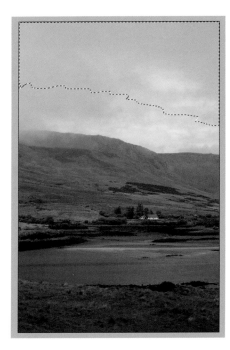

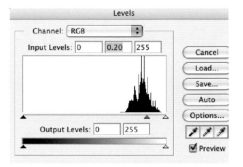

Setting the selection

Like conventional pixel-containing layers, you can cut into adjustment layers to create simple masks or stencils, through which an edit can be made. For complex projects, where quantities of change are not immediately apparent, this technique is an ideal way to maintain full control over image quality and preserve the opportunity to return and change at any future stage.

Start by making a selection, as shown above, and ensure that it is feathered to 5% of the width of the maximum dimension of your image file. For a 3000 x 2000 image, this will be a 150-pixel feather value, enough to blend in the edit.

Using the adjustment layer

Once the selection is in place, make a Levels adjustment layer by clicking the tiny split circle at the base of your Layers palette, third icon from the right. With the selection overlaying only part of the image, you will now create an automatic mask on your adjustment layer. The shape of the mask is shown above, as a simple black and white stencil icon, with white representing the 'hole'.

When making a masked adjustment layer, you can further modify the shape of the stencil by clicking on its Layer icon and then selecting any brush or eraser tool. Regardless of the tool type, the choice of either white or black in the Colour Picker determines whether you increase the hole in the stencil or reduce it. This function is an invaluable way to fit your selection shape precisely around your intended target area, cutting and repairing until the shape is correct.

Determining the change

With selection, feather and mask in place you can now concentrate on adding the precise amount of change to your image.

Double-click on the left of the two icons on your adjustment layer in the Layers palette to reveal the Levels dialog, as shown above. As the histogram shape shows, the area for edit is largely constructed from highlights and pale grey tones. Click and hold the grey midtone slider and push it to the right-hand side, as shown above, and watch your selection go darker. Alternatively, reduce the value in the middle text box, shown coloured blue in the above screenshot.

The results⋯⋗

Five different variations were created by reducing the midtone text box value from its default 1.00, in steps of 0.15. Top left is the unedited image, top middle 0.85, top right 0.70. On the bottom left is 0.55, bottom middle is 0.40, then finally bottom right 0.25. Little or no change is noticeable in the top row, but much more interesting results can be seen at the bottom.

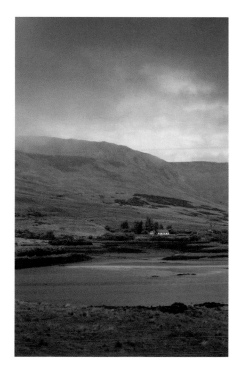
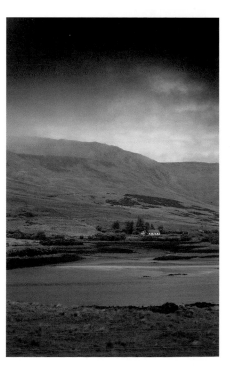

Correcting colour burn

Unlike monochrome printing, making extreme changes to colour images can create many unwanted side effects.

Starting point

This image really needed to be hand-edited, specifically to darken down the two vertical sides of the frame which were too bright. There were also some unwanted details on the left edge.

The best way of darkening down large areas such as these is to use a feathered selection to enclose the desired shape, followed by a Levels midtone edit.

In the example shown above, the area to the right was enclosed in a smaller selection area, and then feathered with a 100 pixel-value edge. This created a soft and diffused boundary between the excluded part of the image and the soon-to-be edited selection area. Any smaller feather value would have created an identifiable edge.

Colour burn

Shown above is a common by-product of editing colour images. When extreme tonal changes are made to the default RGB master channel, colour values can start to burn-out and appear beyond repair. In this example, colour saturation has increased beyond all expectation, creating a very undesirable editing scenario. The increase in saturation also prevents the hand-printer from correctly judging the quantity of change. The same results would be achieved using Photoshop's brush-bound Burn tool.

An identical end-result is often reached when using the Sponge tool, especially if the saturation values are too high or the tool has been repeatedly used in the same area.

Correcting colour burn

After your Levels edit and with the selection still in place, the colour burn can be removed by using the Hue/Saturation dialog box, as shown above.

Found in the Image····▸Adjustments menu, the Hue/Saturation controls provide a useful Saturation slider that can be used to reduce the effects of burn and restore the authenticity of the original area. In this example, the burn was removed entirely by reducing the Saturation slider to -68 on the Master Channel.

The resulting final print, shown right, exhibits none of the previous by-products but only a natural-looking shaded area on both vertical sides. Even extreme examples of burn can be mitigated by this technique, creating a true monochrome printing style.

A further use of this technique is to apply it to individual colour channels in the Hue/Saturation dialog, for subjects that are constructed from single dominant hues or colours.

Contrast on a brush

If elements of your image are too small or too complex to select, then try a simpler method using the History brush tool.

The History brush

Without doubt, the History brush is the strangest tool for any novice image-editor to use, for it has no known equivalent in conventional darkroom practice. Essentially a kind of magic eraser, the tool is not used for removing parts of your image, but to bring back an edited state recently visited.

The process of using the tool is simple. First, make a bold edit and then reverse one step backwards to your previous image state. Next, pick the History brush and nominate the bold edit as the state you'd like to paint back, and then start painting. This way of working is true non-linear image-editing, where you can create and store an editing state to which you can later return.

With this process, you can apply any filter or dialog box command at the end of a brush and even customise the size and shape of your brush to suit the task in hand. There is no need to cut out complex masks, save selections or even adjustment layers. As the sequence is non-linear, no cumulative damage to your image file occurs either.

A similar use of this technique can be developed using the Unsharp Mask tool, where specific amounts of software sharpening can be applied at the end of a brush to very specific parts of an image, to help create the illusion of depth of field or to correct slight camera shake.

Starting point

This example is a typical daylight-lit location shot, taken under overcast conditions. There is little three-dimensional tone present in the image, with flat contrast and subdued colours. However, by using the History brush method it is possible to rescue the project with some sensitivity.

The nature of the original proves to be too complex to use selections and simple burning-in would not solve the issue of low contrast. For this project, I wanted to raise the saturation and contrast in the image without making the end-result look too artificial. Before starting, I identified several areas that I wanted to darken down, including the base of the fountain and most of the shrubs in the garden. By creating dark bases, the effect simulates the contrast created by sunlight.

The final edit was to introduce more yellow overall, using the Color Balance dialog to make the greenery look lush and more alive.

Increase Input Levels contrast

Open the Levels dialog and move both Highlight and Shadow triangle markers towards the centre, as shown above. This has the effect of raising the contrast of the entire image, but you can alter that in the next step.

Select the History brush tool

Open your History palette and reverse back to the previous state, as shown above (shaded blue). Next, choose the History brush and nominate the Levels state, shown at the bottom of the History state list, to erase back to. Now apply the brush to the areas you want to darken.

Breaking up flat tonal areas

More painting than photography, this technique will use your hand-rendering skills to create interest from a bland and uninspiring starting point.

Poor natural lighting is almost impossible to counteract on location, unless you have access to artificial lighting on a film-set scale. Many architectural images captured in poor light, or at the wrong time of day, suffer the same consequences: no texture, no colour and no tonal interest to keep a viewer occupied for more than a few seconds.

This technique is designed to mimic atmospheric natural lighting and provides a get-out when your disappointing original file can't be re-shot. The original starting point for this project was shot in the late afternoon. The sun was in entirely the wrong position - it would ideally have been raking in from the side.

Knowing this would be the case, the image was composed to exclude nearby details that were caught in full-contrast sunlight, as this would have been very difficult to balance with this editing sequence.

Using a large 100-pixel soft-edged brush, apply the Burn tool with a very low 10% value across the areas you want to darken, building up slowly and without extreme jumps in tone. Trace around any natural contours or shapes in the image, taking care to keep your strokes random and not overlapping. This will ensure the end result looks painterly and in keeping with the scene.

Tinting neutral tones

Following on from your hand-rendered shading, add extra colour by using the paintbrush set to Colour Blending mode. From your original, look for any signs of original colours, as this will give you a clear starting point and help to keep the edit believable.

In this example, there were slight signs of mossy green and red brick in the original washed-out RAW file, so these were the colours that were re-introduced to the final print. Use the Swatches palette on your desktop for a simple method of selecting colours.

Saturating back lost colour

The final stage is to draw out as much vivid colour as your subject allows, in this case, the dull green foliage in the left-hand bottom corner. Use the Sponge tool set to Saturation properties and fix the value at 20%.

Slowly apply a soft-edged brush to the desired area. It is better to do this in five or more separate passes than in a single hit, so you can 'peel' back to the bright colours lying underneath. To keep track of the viability of this edit, turn on the Gamut warning, so you can see if you've pushed the values beyond your target media.

Creating an illusion of 3D space

In modelling your two-dimensional digital photograph into a three-dimensional illusion, you are following in the footsteps of all the great figurative painters.

Tonal recession is the term used to describe how colour and contrast fade in value as objects get further away from you. As predictable as perspective, this fall-off in saturation and contrast sends messages to your subconscious brain to help you decide how far away or near things are.

In many original photographic files, three-dimensional space is often compressed due to a number of contributory factors: poor natural light, the way colour is recorded by your chosen file format and the colour of the subjects themselves.

In this technique, Photoshop is used to push different subjects apart, not literally, but tonally, so that the final image better describes a three-dimensional space, with discrete objects within it. Like many of the hand-editing processes in this book, the technique relies on the repeated application of a very low-value brush, so you can build up and ponder your results as you work.

All brush-bound tools in Photoshop can be set to work within three different tonal sectors: the default Midtone, Shadow and Highlight. When your edits start to look disappointing, it is usually because you are using the wrong mode for the area you want to change. If the area is dark, choose Shadows, if it is light, select Highlights and for all else the default Midtones will be just fine.

The original starting point

Shot and saved as a high quality JPEG, the starting point for the project looks very flat tonally, low in colour intensity and with a reduced depth. The plan was to trace a darker shape around the central tree to enhance the contrast between it and the big green bush behind.

I also wanted to strengthen the colour saturation in the sky and try to make the grass more vivid. Overall, these edits would pull and push different image elements forwards and backwards, so the final print would look much more interesting.

Enhancing natural shapes

To start with, the Burn tool was set with a soft-edged brush and used to trace around the edges of shapes within the image. The tool's properties were varied between Midtones and Shadows, as it was worked slowly around the image. For the entire project, I used about fifty separate strokes of the brush set to 10% Exposure.

This technique has the effect of raising apparent contrast without using Levels or Curves. To add saturation to the sky, I applied a simple Transparent to Foreground linear Gradient, starting from the top of the frame and ending just above the trees. To ensure a convincing blend of new colour, I used the Gradient on Colour Blending mode, so the strong blue did not remove any underlying detail. Finally, the most distant tree was lightened with the Dodge tool to make it look further away than it really was.

Enhancing lines and edges

Learn how to make simple masks, so you can radically change the balance of your images and invent tone that was never there in the first place.

 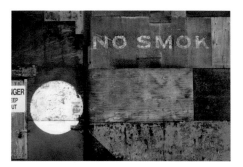

Analysing the start

Don't be deterred by the absence of interesting tones in your original file. You can easily draw them in using simple selections and the Burn tool. This original image lacked any kind of contrast or tonal separation, so the plan was to place a selection fence around several identifiable shapes and then darken down, to create more light and dark. The plan also included a crafty edit to help make the faint white lettering more visible.

Unlike straight hand-editing using the Burn tool or any other brush-bound device in Photoshop, this method creates a straight edge, over which the edit won't occur. It's ideal for hard-edged areas of an image, such as the example shown. Attempting to burn-in a straight line is impossible, however skilful you are. Ensure that the selection, however tightly traced around the source shape, is set with a very small amount of feathering, such as a 1-pixel value, as this will help to hide any slight errors in your original tracing.

Darkening the selected area

Once contained within an enclosed selection, shown above, the area in question was darkened down using the Burn tool. This was set with a brush size which would be small enough to work within the enclosed selection area, but large enough to easily overlap itself during repeated strokes, without leaving tell-tale circular brush marks.

Making a selection like this can also provide the equivalent of a straight-edged ruler, if you need to enhance a line rather than the entire area of an enclosed shape. Simply draw the selection as a closed-up shape and trace along one side.

Brushing your soft-edged Burn tool against a hard-edged selection will mean that the diffused edge will be inside your selection area, rather than outside, and so create a convincing amount of fall-off against the hard edge.

To darken, place the centre of the brush directly over the selection line and then drag the brush in your chosen direction, building up slowly.

The finished result

The example above shows several areas that have been darkened down using this method. In addition, the immediate spaces surrounding the lettering have also been darkened, to make it noticeable.

An alternative ending

The example, shown right, uses exactly the same technique to introduce tone where none existed. The original file is shown below, demonstrating a very dismal tone and colour palette. Colours were enhanced using Photoshop's Channel Mixer tools, to convert greens into pinks and rust into greens.

Maximising saturation

Poor colour intensity can be due to a number of different factors, but there are many ways to resurrect saturation back to its original levels.

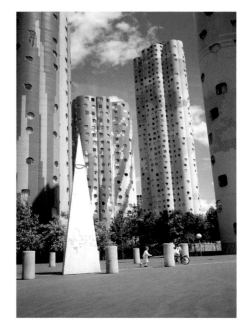

Starting point

This original was scanned from a medium-format transparency, but lacked the same colour intensity as the original by a long way. Low colour values are easily identified if you open the Hue/Saturation slider and play with the Saturation slider.

Only small quantities of saturation are possible before strong colours move out of gamut for your printer, paper and ink combination.

Keep your edits down to +20 or lower and ensure that you keep the Gamut warning switched on, especially if you are targeting a final CMYK output, where colours will be less vivid overall.

Global editing

Open the Hue/Saturation dialog and make sure the Master channel is selected from the Edit pop-up menu. Drag the Saturation slider into positive values, starting with +20. This will refresh all colours simultaneously, or those set in a selection.

Individual colours

A more sophisticated command can be made by choosing individual colours from the Edit pop-up. In this example, the Blue colour was saturated, creating a richer and more contrasty sky, but leaving all other colours unaffected.

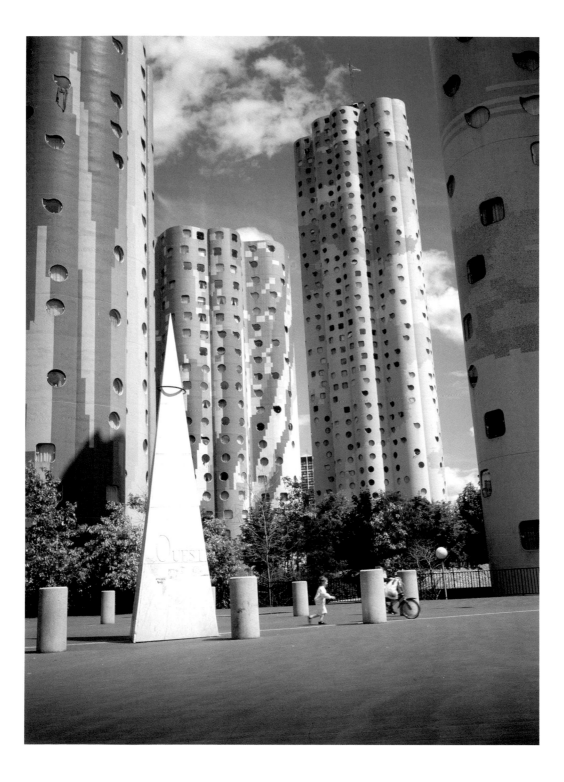

Signature edges

There's no reason to print your images with clean-cut edges, better to think about adding your own personal signature instead.

Borders and boundaries

Despite the apparent good sense of trimming your final prints to create clean, squared-up edges ready for display, it is well worth considering a more hand-crafted approach. Adopted from the numerous darkroom techniques where all manner of black and raggedy edges were introduced to the print, the best digital re-creations can help to raise the impact of your final print.

Signs of human intervention are good and help to define your printing as a craft skill rather than the mechanical operation of a software routine. Edges are easily included during the scanning phase, or if your originals were captured in-camera, borders can easily be combined as an extra layer in Photoshop.

For this example above, a print was made on textured cotton art paper, then finished by hand with a soft 4B graphite pencil. Scratchy edges, smudged into some of the print area, makes this into a one-off digital print.

Ragged edges

Above is a good example of ragged edges, extracted from a high-resolution scan of a heavily over-exposed frame of Kodak Infra-red 35mm film. This film is naturally grainy and further enhanced by excessive over-exposure and processing in HC-110 developer. When scanning, the standard sized 24 x 26mm aperture in my scanner's film-holder was enlarged with a metal file, to create this extra space around the film original and an irregularly shaped cut edge to the scan. Each subsequent scan with this adapted holder shows the same personalised edge.

Film rebate edges

Although there are numerous plug-in applications for Photoshop offering a choice of creative edges within which to frame your images, there's nothing quite the same as an original film rebate edge. This example, right, shows a black and white 35mm negative scanned through the aperture of an oversized film-holder, in this case for 6 x 4.5 format film. By clamping the film carefully in the holder, you can easily scan the rebate to include frame numbers, processing marks and anything else lurking on the edges that would enhance a hand-crafted look.

Chemical styles

Combining colours, tones and unpredictable contrast effects, were all part of a darkroom expert's creative armoury, but you can reproduce similar effects with Photoshop's Layer blends.

Starting point

All conventional chemical printing effects rely on a manipulation of tone, colour and contrast, usually with bleaching or reducing agents. Chemical styles such as lith printing or sepia toning, when done to a high standard, impart an alternative feel to a finished print, elevating it above the mechanical product, closer to a one-off hand-finished artist's print. Contrast and toning effects can provide an extra 'bite' to otherwise flat and mundane images, making them look more arresting.

A good example to use for a chemical technique is a plain monochrome image, devoid of any dramatic lighting or atmosphere, but with a range of visible texture. The above shot was captured in soft sunlight and has little more than textured prints in the sand to focus your attention on. The purpose of the edit is to make this more striking and more atmospheric using Layer Blending.

Toning and duplicating layers

If you have an RGB camera or scanner image to start with, remove all traces of colour by doing an Image----} Adjustments----}Desaturate command.

This sweeps away all colour, but leaves your image in the essential RGB colour mode. Next, apply an all-over wash of tone to your image using the Colorize command and the Saturation slider, as found in the Hue/Saturation dialog box.

For the example above, a very low value of saturation was used to keep the overall colour subtle rather than overblown.

Once you are satisfied with your base colour, duplicate the background layer by doing a Layer----} Duplicate Layer command. Do not be concerned at this stage if it looks flat and uninteresting.

You will now have two identical layers floating above each other in your Layers palette, as shown above.

Layer blending with Linear Burn

Once you have the two identical layers in place, experiment with the different layer blending modes, as found within the pop-up menu on the top left of the Layers palette. By default, the Blending mode is set to Normal, where no colour reaction takes place between different layers.

Yet, once this is altered away from the default, colours will start to react to each other in an unpredictable manner. The examples above and right were created using the Linear Burn blending mode, combined with a reduction in the layer opacity to 55%, applied to the uppermost layer in the palette.

The effect mimics the look of a traditional darkroom lith print.

A plain monochrome image was enhanced using layer duplicates to mimic lith printing. ▶

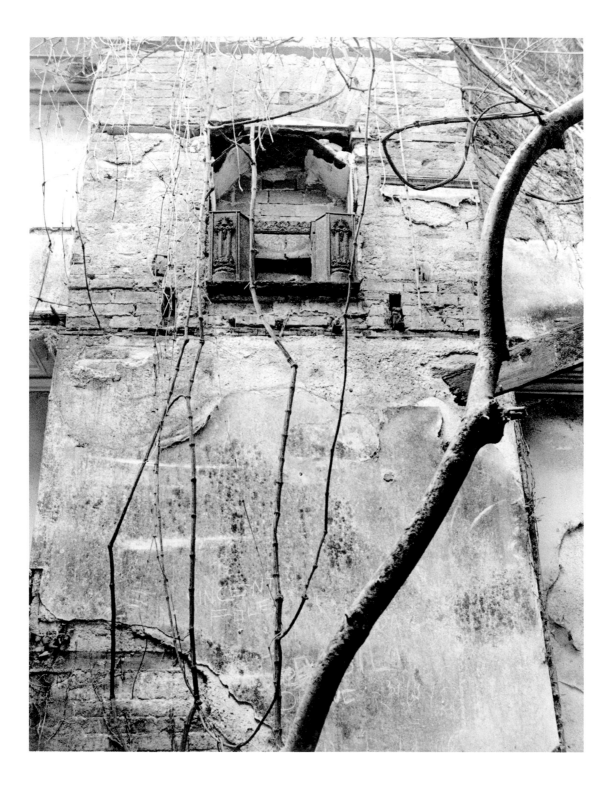

Custom paper coatings

Like early photographers who prepared sensitive materials in the field, you can now buy liquid inkjet coating media to create your own unique paper surfaces for printing

How they work

All purpose-made inkjet media has a thin layer of absorbent coating applied to the paper base, to accommodate the minute ink droplets. Coatings are specially designed to maximise reflectance from the media and therefore maintain both colour saturation and contrast. Glossy, matt and stipple finishes are all essentially produced by the different types of coating applied in the manufacturing process, but now there are innovative products available to create your own one-off surfaces to print on.

New products on the market, such as the InkAid range, provide the photographer with a versatile paint-on media, in both white and colourless transparent variations, which are applied to the paper, then dried before printing takes place. Like liquid photographic emulsions, InkAid pre-coats are applied to unconventional media such as uncoated artist's paper, wood, metals, ceramics and textiles, providing a purpose-made surface for regular inkjet ink to sit upon.

Aimed originally at artist-printmakers rather than photographers, the InkAid range is designed to work closely with modern pigment inks and desktop inkjet printers. Bespoke coating can also be made using a very traditional product: rabbit skin glue, melted down and brushed onto the receiving media to provide an unusual key for your ink.

Coating and printing

Liquid coatings are easily applied using a soft, sable brush or by a glass coating rod, depending on what kind of surface you want to prepare. Visible brush marks may contribute to the overall effect, especially if you want to create brushy edges, as the example opposite shows. Like all transparent coatings, the InkAid clear gloss pre-coat is suitable for use on all media where you want the nature of the surface colour to show through.

For non-porous media such as ceramic tiles or plastic, a separate adhesive must be applied first to create a key on the surface, so the costing can grip better. Although rabbit skin glue is an affordable option compared to the specially produced pre-coats, it is unflexible and will easily crack off non-porous media in the future.

A transparent coating applied to cream paper, for instance, will accept ink, but the maximum highlight value of the image will be the natural colour of the coated paper i.e. cream. White pre-coat medium should only be used where the original paper colour is undesirable, or where you are able to produce perfect registration between coating and print out. The quality and opacity of white InkAid pre-coat will hide most vivid paper colours with two coats.

With all hand-made coatings, some degree of testing will need to be carried out to establish the best settings to use. Prepare smaller sheets of pre-coat material,

using the same application method and quantity as you intend to use for the final piece.

Use the smaller sheets to test on, trying different media settings in your printer software and different printer resolutions. Hand-made coatings may not be able to cope with ultra-fine printing out at 2800 dpi or beyond.

For specialist output on to non-flexible media, such as wood, metal or ceramics, a flatbed printer such as the Encad is necessary, or a device used by commercial silkscreen printers. Designed to 'float' over rigid print materials, the flatbed printer can be used to output onto large-scale pieces for gallery use.

Mixed media

Many artists use pre-coatings to enable the overlaying of paint and ink, or vice-versa, onto prints. The general rule for creating any mixed media work is to ensure that separate colouring media, like paint, ink and pre-coats are all acrylic or water-based. Any subsequent mixing of oil-based inks or paints with acrylic products could render the piece unstable. Like photographic emulsions, pre-coats can be scratched, tinted and manipulated, to create a much more hand-rendered print.

A brushy-edged image printed onto cream Fabriano paper using a clear pre-coating. ▶

Split-grade printing

This technique allows you to mix high-contrast and low-contrast versions of the same image into a final print-out and helps to avoid burning-in complex shapes.

Resourcefulness is a key term to remember when looking back to the methods devised by professional photographers to manipulate image contrast with very basic silver-based materials. Faced with complex shapes too tricky to burn-in, a special method was developed using multi-contrast printing paper.

The print paper was first exposed using low-contrast filters to register the highlights, then a second exposure using high-contrast filters was made to deepen the shadow areas. The result was the most perfect blend.

Faced with similar circumstances, a much simpler method can be used in Adobe Photoshop using layer blends and duplicate layers. To retain maximum control over contrast in this edit, use Levels adjustment layers for both the high-contrast background layer and the low-contrast duplicate layer, so you can return and edit until ready for print-out.

For very specific problems, perhaps where only smaller areas of your image require contrast modification, consider using Photoshop's Curves controls, within a feathered selection area, so you can manipulate the exact tonal sector in question.

Curves are also offered as adjustment layers and you can identify a target tone from your image by clicking the dropper tool into it.

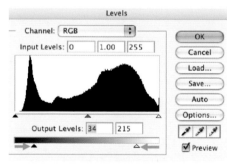

Prepare the low-contrast layer

Open the high-contrast original, then duplicate background layer, so you have two identical versions of your file lying above each other in the Layers palette.

Next, do Image⇢Adjustments⇢Levels to bring the Levels dialog up on your desktop. The purpose of the next step is to lower the contrast of the uppermost layer, creating greyish, rather than bright white, highlights.

Drag the two triangular sliders in the Output Levels scale towards the centre, as shown in the dialog box above. This will determine the new bright and dark values

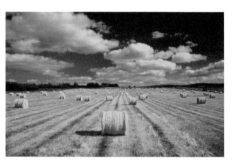

Blend together

Once your soft and hard layers have been created, the Layers palette should look like the example above.

Next, to create the blending recipe, click and hold on the pop-up menu found at the top left-hand corner of the Layers dialog, which by default will display the word Normal. Choose Multiply as the blending option and watch how low and high-contrast layers start to merge.

A further control can be made using the Opacity slider, so you can alter the transparency of the uppermost layer. This final example, right, had a 50% value.

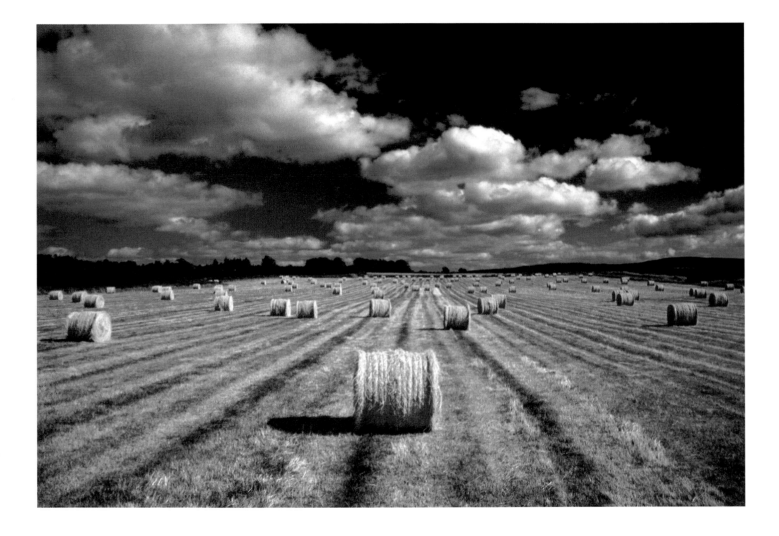

Pre-fogging

Awkwardly shaped bright highlights can be impossible to darken down, if you desire a subtle overall result.

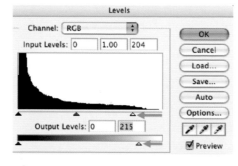

Starting point

The traditional process of pre-fogging was invented to compensate for the harsh realities of unforgiving printing paper. Before the main exposure took place, the negative was removed from the enlarger carrier and an almost imperceptible layer of grey was laid down with a short pre-exposure. The resulting material printed softer, without the need for complicated burning-in. It became a very desirable style in its own right, long after printing materials became more sophisticated.

For digital users, it is still possible to re-create this effect by the careful manipulation of one single dialog box. For the following technique, choose an image which has strong highlights arranged in such a way as to make hand-editing very difficult. The end-result can look very atmospheric and transport the perceived creation date of your print back to the pre-digital era.

Fogging the highlights globally

Complete all the hand-editing before beginning the pre-fogging. Next, open the Levels dialog and move the Output Levels highlight slider triangle towards the centre, as shown above. This will create grey rather than white highlights across the entire image. Aim for an Output Level of 215-225 in the text box.

Next, repeat the same for the Input Level highlight slider, until you can see a slight increase in contrast, without changing the new tonal value.

Fogging selected areas

For smaller areas of the image which may need additional editing, this same process can be applied until you have achieved the correct balance.

After the global change to the highlight tone, use the Lasso Selection tool to make a simple enclosed shape around the area you want to alter. Next, apply a Feather value to ensure the edit doesn't look too obvious, or seep into adjoining areas.

From your Levels palette, drag the Output Levels highlight slider across, as shown in the previous step, until the highlight area becomes less noticeable.

The final print, opposite, was produced with an additional split-tone colour to remove all existing naturalistic hues and to create a more evocative print. The look and feel of a pre-fogged print can be further enhanced by output on a semi-matt, heavyweight inkjet paper such as Harman Warmtone.

Chapter 7
RAW MATERIALS

Profiling your ink and media

Bespoke printer profiles are the most accurate method of producing top-quality prints from a professional workstation and are well worth the initial expense.

You'd never spend a few thousand pounds on a digital camera system, then skimp on a cheap lens. Similarly, it is false economy to skimp on printer profiles. Designed to offer maximum creative flexibility and at the same time produce faultless printed output, the professional inkjet printer won't produce the goods unless you invest in proper profiles.

For all branded media, printer manufacturers like Epson and Canon provide generic profiles as standard in the printer software, which you choose in the printer settings. But for more discerning users interested in experimenting with third-party inks and paper, these pre-supplied profiles fall way short of providing suitable guidelines for obtaining quality results.

Bespoke profiles are ideally used when you have settled on a favoured ink and media combination and when you are determined to use this over a prolonged period of time. For shorter printing projects, one-offs or experimental work, the cost of commissioning such profiles can be prohibitive.

Profiling hardware was for a long time the preserve of photo-labs and repro houses but prices have fallen dramatically over the last two years, putting a basic kit well within reach of a professional photographer, camera club or the seriously keen.

Bespoke profiles are obtained in two ways: either by the use of a remote profiling service or by the purchase of a hardware profiling kit. Remote profiling services offer a simple and effective way of generating a purpose-made profile for a relatively low cost.

Once you have selected your service provider, you download a sample test image file, print this off on your device with your choice of paper and ink, after taking a careful note of the settings you have used in your printer software. The physical print is then returned to your service provider by post, where it is measured using a sophisticated device. The profile file is then created and emailed back to you for instant use. The only downside to this is the cost: usually £25/$50 per profile, so not an option for testing several different output media or inks on different printers.

On the other hand, hardware profiling kits offer the option of a higher start-up cost, but effectively unlimited profile creation thereafter. At the budget end of the range are the hand-held readers, which have to be used slowly and with due care and precision. At the other end of the range are the automated readers, five times the outlay and quicker to use, offering a hands-free operation.

The Eye-One kit, shown opposite, is an innovative device offering both monitor and print profiling from a single unit.

Printer test chart
An integral part of making any bespoke printer profile is the test chart image file, as shown above. Printer profiles work by correcting the deviation from the expected colours based on the performance of an individual printer and as such can be much more accurate than a generic profile supplied by a manufacturer.

To measure this deviation from the norm, a specially prepared colour test chart is designed and made available as a digital file for each user to open and print out. Once created, the test print can then be measured to detect any imbalances resulting from the performance of your own individual workstation and environmental conditions.

The Eye-One profiler

A multi-purpose device that can produce
both monitor calibration and output (print)
profiles. Shown above is the hand held
measuring device, taking a reading off a
specially printed chart which has been
produced using a specific combination of
paper, ink and printing device.

Installing profiles

Once created or downloaded from a manufacturer's website, it is essential that you place the profile data file in the right folder and configure your software with the correct settings.

Profiles are designed to enhance your printing quality by storing optimum settings, so you don't have to keep experimenting with printer software controls. However, the placing of the profile file and its subsequent use, can be baffling for the first-time user.

The purpose of a printer profile is to ensure that a paper's inherent colour reproduction characteristics are corrected invisibly within your application, saving you time, effort and resources. Many manufacturers make available printer profiles so you can get the best results out of the paper straight out of the box. Profiles are actually small data files that are created and saved in the universal ICC format, described with the .icc file extension on the end of the filename. All profiles are limited to correcting one combination of printer model, ink type and paper. Change any part of this recommended combination and the profile is useless. The downside of using a manufacturer's own profile is that it has been created in universal laboratory conditions, which may not be the same as your own working desktop environment. The universal profile will never take into account the age of your printer, or any other factors that are unique to your workflow. ▶

The same file printed with profile, top, and without profile, bottom. Notice the extreme change of colour balance.

Installing the profile

Clear instructions are provided with most profiles showing you where to place the file depending on the type of computer and operating systems. Check that the downloaded file is first extracted from its archive package before installing it onto your hard drive.

On an Apple Macintosh computer running OSX, profiles are placed in the Color Sync folder, which is found through this route: MacintoshHD····⟩ Library····⟩ ColorSync····⟩ Profiles.

For Windows 2000 users, the files are placed in C:\WINNT\Spool\Color.

For Windows XP users, files are placed in the following directory: C:\Windows\System32\Spool\drivers\Color.

Tuning-up Photoshop

More important than the locating of the files within your operating system are the instructions for ensuring Photoshop reads the custom profile when working. Evidence that the profile has been acknowledged by Photoshop can be checked by opening your chosen file then selecting the Print Preview or Print with Preview dialog box.

At the base of the dialog box, ensure that the Show More Options button is selected, which reveals an extra panel of controls. Select the Color Management option from the pop-up menu, then click and hold the Print Space pop-up menu. Within this menu, you will see all the profiles loaded onto your computer, including input, monitor and output profiles. If the desired profile is not visible, you need to double check that you have placed it in the correct directory and start the proces again.

Select the chosen ICC profile and alter the Intent as shown in the Print Space pop-up menu. The Intent controls allow you to decide on the precise method of colour-value conversion and ensure that Photoshop targets the nature of the medium when preparing for print. Black Point Compensation is an essential factor as it precisely limits the shadow limits on your file, so your final print doesn't fill-in.

Configuring printer software

Next, the printer software dialog box needs to be adjusted to reflect the recommended media settings. In this instance, the paper profile installed was for a specialist inkjet paper calle Harman Warmtone. With the paper product came instructions for downloading a profile that matched my Epson 2100 printer. With the profile file installed, the next step was to set the recommended media settings. Harman advised that the Media type be set to Watercolour Paper- Radiant White media option, as shown above.

Although the profile undertakes the invisible task of converting undesirable colour values into more acceptable ones, it does not control your own user-defined settings. The printer software settings must therefore be checked each time a print is made in case they have defaulted back to another combination.

At this point, select the desired resolution of the printer too, in this case the Photo 1440 dpi. Keep these settings identical with each print and the profile will always give you the same results each time. By reducing the number of variables that could potentially alter your print-out, profiles allow you to concentrate on the more demanding task of creatively manipulating your file.

Colour management settings

The final setting is made to the printer software's Colour Management controls, which are all turned off. Don't be tempted to add another variable at this point and allow yourself to make colour corrections in the printer software or you might as well ignore the profile.

Once set, you can now rest easy and start printing. In addition to using the output profile in this manner, you can also use it to soft-proof the likely results of your printed image on your desktop. In Photoshop, do View·····⟩Proof Setup·····⟩Custom and choose the Harman profile from the Profile pop-up menu. Select Perceptual and Black point compensation options and you can preview on your desktop monitor the likely look of your image on your targeted paper stock.

Finally, avoid assigning the printer profile to your oringinal file as its nominated colour space. In Photoshop's Color Preferences dialog box, opt for the Adobe RGB (1998) colour space option which tags your file with the biggest colour palette available. This gives you maximum flexibility to print onto other papers in the future and target as many different output profiles as you can afford.

Testing media

If you don't have bespoke profiles for each combination of paper, ink and printing device, you will need to establish your own tests and draw your own conclusions.

The greatest impact on your image contrast can come from an incorrect selection of the media type in your printer software. This is usually the case when using a different media brand to the printer, as, for obvious reasons, printer manufacturers exclude competitors' products from the list of media options. Confusion can grow more intense when recommended media is rebadged with a different name that doesn't correspond with any of the options in the media settings dialog. To avoid such a dependence on presets, it's a much better idea to stick with one media setting for glossy and one for matt paper, set your printer resolution to 1440 or 2880 dpi and leave well alone.

Printer software presets

Unexpected results often stem from the use of printer presets such as auto contrast, Auto colour correction or Auto sharpening. You'll never be able to predict exactly how these commands will change your image, so these are all best left unselected in favour of an entirely manual preparation in Photoshop before getting to the printing stage. All printer software comes pre-loaded with largely hidden profiles that have painstakingly been developed to get the best out of set ink, printer and paper combinations and these will give excellent results for most project work.

Paper differences

Despite the name on the box, there's a world of difference between inkjet paper bought in sheets of 500 from a high street stationers and photo-quality paper made by Canon, Epson or Somerset. Cheap papers will never give you good results, however long you spend tweaking your software settings, as they do not have the necessary coatings to cope with fine dots of ink. Cheap paper gets soggy, lacks rich contrast and presents poor colour saturation regardless of the perfect image on your monitor. Always invest in good quality media and ink, or your painstaking hand-editing will never print as you intend.

Paper and printer testing

Different papers will respond to different printer software settings, but may still need additional correction to achieve a flawless print. The idea of testing your paper beforehand is straightforward and in the long run very cost-effective.

Testing involves finding the exact points at which the paper can't separate dark grey from full black and pure white from light grey. Once this has been established and accounted for, your prints will no longer burn out or fill in. The image file, shown opposite, was developed to demonstrate how different paper types cope with midtone, highlight and shadow values.

Keeping electronic notes

Through the process of testing your media, it's vital to keep detailed notes of your printer software settings. A good method of doing this is to create screenshots of each dialog box encountered on your journey, so you have the exact reference to return to at a later stage. Both Apple and Windows-based PC's have a screen capture utility which allows easy capture of full screen or nominated windows. After capture, screenshots are stored as .bmp, jpg or other file formats which are easily viewed later on.

Don't print them out if you are embarking on a comprehensive test, but store them in a folder and watch them again as a slideshow in either Preview on Apple computers, or Windows Media Viewer. This way you can see each dialog box in sequence with the exact settings.

Making a test file

This example file, right, was designed to test a monochrome image for print-out on a sheet of A4 paper. The purpose of the test was to achieve a neutral colour-balanced result with detail and tonal separation throughout. Each vertical column was prepared with a varied amount of difference in the Levels Input Midtone text box, from left to right: 1.20, 1.00 (default) and 0.80.

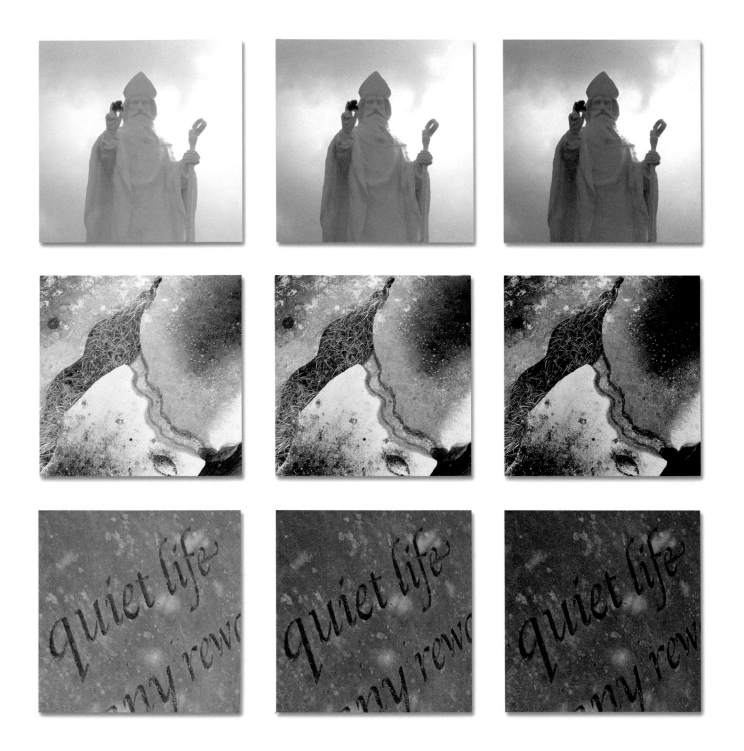

Test printing

Test strips help you to solve simple problems quickly and make better use of costly ink and paper consumables.

If you've taken time to colour-calibrate your monitor and even worked out the best printer software settings for your paper, there's still no guarantee of perfect prints each and every time. Central to the craft of conventional darkroom printing is the test strip. When thin pieces of photographic paper are painstakingly exposed to different amounts of light, the photographer generates a useful selection of variations to choose from. Yet digital image-makers rarely print out variations and place too much trust in the self-correcting nature of printer software. When prints turn out wrong, most of us try another combination of printer software settings rather than modifying the image in Photoshop.

With this straightforward technique, there's no need to copy and paste tiny image sections into a new document for proof printing. Instead, you can print a selection area onto a small sheet of paper from the very image you are working on. Any paper size can be used, but it's much more economical to set up a custom paper size in your printer software beforehand. Every printer has its limitations on minimum media size, but an A4 sheet cut into four quarters will give you enough paper to test at least one image. Its rare that you'll need to make more than a couple of different test strips, but if you do, then it's a good idea to label them with any corrections that you make.

Printer limitations

Never adjust image size or resolution between tests and final print, or you will need to start all over again. Any significant change such as this could alter the colour balance, contrast or sharpness.

When test strips are ejected by the printer, its important to let them dry before making your decision, as some papers with sticky top coats can take a couple of minutes to absorb ink and dry. Always judge your results under natural daylight from a nearby window, or within a specially designed daylight viewing booth with a corrected light source.

To judge the best from your test, it's important to realise that monochrome, duotone or Hue/Saturated control toned images frequently print darker than expected due to the way RGB image colours are translated into printer ink values. If they do, try using your Soft Proof controls to predict the likely outcome before sending to print.

Shadow areas can also start to fill in and prevent image detail from appearing. Colour prints also become much less vivid especially when printed with pigment inks and uncoated papers.

Look for detail in the shadow areas, but ignore colour balancing and lighter than expected highlights as these are easier to correct later on. A correct test will not produce a finished print, but will provide you with a starting point for hand-editing.

Defining the test area

Once your image is ready to print, select the rectangular Marquee tool. Make sure the Feather value has been set to zero, then click-drag a rectangular selection that includes a cross section of highlights, shadows and midtones.

On portraits, this should be based on a skin tone area. Ensure that this selection area is smaller than your intended printing paper. On the example shown above, a selection was made to include the deepest black, the whitest area and the dominant blue sky colour. The resulting test will demonstrate how these areas will print.

Test 1: too light
Milky shadows and washed out strong
colours define the first attempt.

Test 2: too dark
This test was over-corrected, showing
filled-in shadows. Don't be tempted by
rich colours, as these are easily added.

Test 3: Just right
With visible detail in the shadow areas,
this is the ideal starting point for a
hand- printing excercise.

Sending to print ···
To make your printer software recognise
your selection, from the File menu choose
Print Preview and in the printer software
dialog box, select the Print Selected Area
option. If this not available, you may have
a feathered selection applied.

This command will print your selection
in the centre of your chosen paper size.
It's important to use the same paper for
both test and final print, or you'll get an
inconsistency that you can never resolve.

Print

Position
Top: 9.28 cm
Left: 6.84 cm
☑ Center Image

Scaled Print Size
Scale: 100% ☐ Scale to Fit Media
Height: 9.031 cm
Width: 5.997 cm
☑ Show Bounding Box
☑ Print Selected Area

Print...
Cancel
Done
Page Setup...

☐ Show More Options

Baryta papers

Specially coated inkjet media is designed to reproduce both maximum detail and image sharpness and will create a very professional appearance.

Branded as a professional fibre-based inkjet medium, coated papers promise to lure digital photographers frustrated with generic inkjet media. On first inspection, this kind of paper feels luxurious and weighty, manufactured close to a double weight conventional photographic paper. Many papers are designed with a clever baryta layer within, whch helps to keep the paper rigid and improve the brightness of the image overlay. The use of baryta makes an exciting link between this new material and some of the old darkroom favourites.

Using the paper

Before starting to print, it is a good idea to run a printer head cleaning routine so you can be confident that any unexpected colour imbalance cannot be blamed on the condition of your desktop print heads. Whenever using a dedicated output profile, I always make a test print first without the profile, so I can see just how dramatic the correction is. Profiles do make a significant difference to the quality of the outcome. Importantly too, is matching the correct media setting in your printer software dialog box, as anything other than the recommended one will result in wildly colour-cast prints. The test file (shown opposite) was devised to print out a range of monochrome images, each with a different 'exposure' and contrast range, so I could see how the paper performed under different conditions. Three desaturated RGB images were prepared, each with three tonal variations using the Levels dialog. For the dark versions, I used the Levels Midtone slider to drop the Input Midtone value from 1.00 to 0.70 and did the same amount of alteration for the light versions, moving from 1.00 to 1.30.

Characteristics

The most impressive feature of coated paper is its ability to render a neutral black and white print created from a colour inkset, which is no mean feat for any photographer struggling to eliminate unexpected colour casts. In this respect, the profile did a very good job of keeping the final piece strictly mono. I prefer to print my mono images using the full colour inkset, as the print resolution is greatly enhanced by the use of six or more colours. Each of the test prints I made using the Harman Warmtone inkjet media demonstrated a crisp sharpness, showing the finest detail in my images. The paper was also very capable at dealing with excessive black shadow areas too, even the deliberately darkened test images printed very well without clumping together difficult to print tones. These characteristics mean that the paper is likely to receive very good reviews from the black and white photography fraternity.

The results bear out very well the claims made for the advantages of the baryta sub-base. Not only does this special layer create an ideal environment for printer ink, helping to maximise sharpness and tonal range, but it also contributes to extended archival qualities.

Each print emerged from my inkjet curl-free and without any visible wet ink; indeed the paper makes a very good job of drying quickly compared to other brands.

This Warmtone baryta paper made by Harman, provides a cast-free medium for printing highly detailed monochrome images.

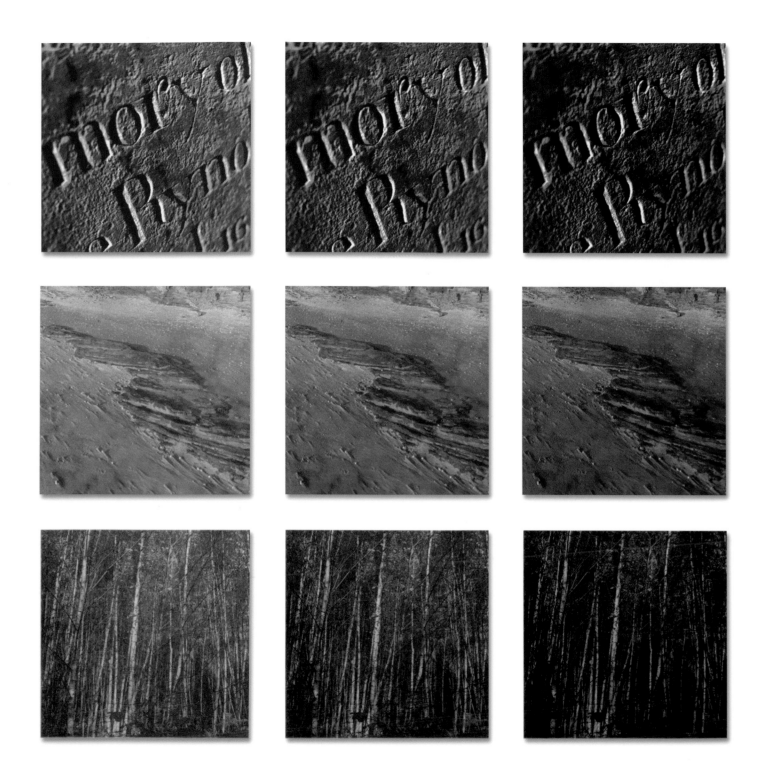

Matt and uncoated papers

There are simply too many exciting paper materials to limit your output to photo-glossy media. Experiment with surfaces, coatings and non-traditional materials to give your image the edge.

Testing uncoated papers

Using artists' or plain old writing paper can provide you with a really interesting printed effect. Top quality writing papers, such as those with a laid or bonded impregnation, are ideal media to use for monochrome printing.

Arriving at a suitable formula in your printer settings, however, is much less straightforward than expected. The example below is a test print made on Conqueror writing paper, using the settings meant for plain paper. When uncoated papers are used with an inkjet, the tiny globules of ink bleed into one another, providing a softly focused and somewhat darker than expected result. Prepare your image lighter than usual and opt for the 360/ 720 dots per inch printer resolution option in your printer software.

Don't expect super-rich tones, but accept the media's inherent but limited qualities to produce something different from the regular shiny inkjet print.

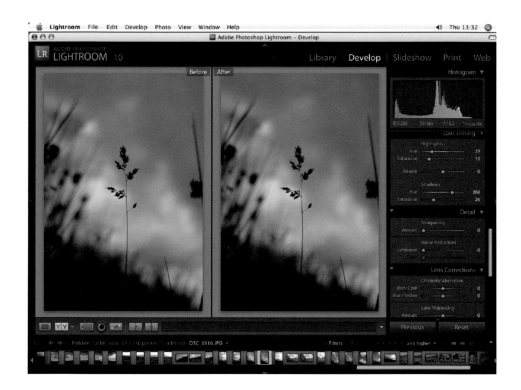

Preparing in Lightroom

Matt paper stock responds well to subtle, low-key images, which have been prepared without contrast extremes. This example, above, was such an image which was shot in changeable lighting conditions.

When opened in Lightroom, the option to display the before and after panel was taken, so I could compare the tonal changes I made on the way to prepare for print-out. In Lightroom's Develop module, the highlights were pulled back until they were a creamy grey rather than bright white. The result was a much softer image, which in turn was ideally prepared for split-toning. Using Lightroom's excellent two-slider Split-Toning function, a pale yellow was applied to the highlights followed by a reddish purple to the shadow areas. The final full-sized print, as shown opposite, was perfectly suited for output onto a low-contrast smooth matt-coated inkjet paper.

Chapter 8

OUTPUT OPTIONS

···⟩ Professional inkjet

···⟩ Silver output

···⟩ Large-format output

···⟩ Printing on-demand books

···⟩ Inkjet book kits

Professional inkjet

More versatile than a consumer inkjet, the professional range is supported by sophisticated pigment inks and has the facility for large-scale output.

Desktop inkjet

Aimed at the professional photographer and priced at around three times the cost of a standard A3 desktop inkjet, the Epson Stylus Pro 3800 is a versatile output device. Occupying much less desktop space than the 4800 opposite, the device can use the same Ultrachrome K3 inkset with nine different colours to choose from, in an eight-slot configuration.

Professional output devices are now mostly A2 in size, enabling photographers to create traditional exhibition-sized prints from their desktop rather than using a specialist lab. The traditional 16 x 20 inch darkroom print can easily be made by the 3800, but unlike the 4800, there is no roll paper option.

Able to cope with large packets of data through it's USB 2.0 interface, the printer can also accept individual sheets up to a maximum 1.5mm thickness.

The benefits of investing in a professional printer such as the 3800 are the excellent record of stability and lightfastness that accompanies Epson pigment inks and media.

Prints made from all K3 inkset supporting devices are safe for resale and editioning and are supported by Epson's own certificates of durability, should you wish to increase customer confidence in your print products.

Types of black

Good inksets such as the Ultrachrome K3 family enable photographers to use standard black, light black and light-light black in the same output session. The brand also provides two alternative standard blacks: Matte, for output onto non-shiny surfaces and Photo for output onto all others. The cartridges can also be easily re-inserted between different sessions.

Proofer-style inkjet

Capable of making prints up to A2 in size, the proofer-style printer has a large desktop footprint and high-capacity ink cartridges.

A good device for professional photographers to invest in, this kind of output device will print onto roll paper, single sheet-fed special media and the usual cut paper sizes in large quantities. Fitted with three separate paper-feeding mechanisms, this printer will cater for most general practice commercial photographers, keen to control their own output quality and profit margins.

Three blacks are fitted, with eight separate colours in easy-to-access front-loading slots, to create high-quality monochrome output. The cost of the high capacity 220ml cartridges, however, can be nearly 50% of the cost of the device itself.

The Epson Stylus Pro 4800 printer, above, is a high-resolution device creating variable-sized ink droplets for output at up to 2880 dots per inch.

The printer can run with Ultrachrome K3 pigment inks which have an estimated lifespan of 75 years for colour and 100 years for monochrome output.

Unlike most A3 desktop inkjets, the 4800 is extremely rugged and built for repeated studio use. The manual sheet feeder can accept media up to 1.5mm thick, which includes most heavyweight fine art papers such as Somerset Velvet Enhanced. An ideal tool to use for making editions of your work for exhibition, the 4800 is fast and stable over long print runs and large-sized output.

The printer accepts 17" wide paper rolls, the most economic way to make prints and has a built-in guillotine for making precise cuts on roll-fed media.

Silver output

Designed to offer the best of both worlds, silver-based output devices offer lightfast printing from most kinds of digital artwork.

Many professional photographers still trade in silver-based prints, especially wedding and portrait specialists, to re-assure their clients about the lifespan of commissioned work. A typical output device is like the mini-lab found in most city centre photo-processing services, with built-in processing chemistry, exposure unit and finishing equipment. However, unlike the traditional mini-lab, the digital versions use a laser diode to 'beam' digital data straight onto conventional photographic paper. Print quality from these kinds of units is exceptional compared to traditional processing, taking advantage of crafty software processes to enhance colour, contrast and sharpness. A digital mini-lab print is pin-sharp with vivid colours and this is a very economic process for high-volume jobs needing a fast turnaround.

These services are easily accessed through kiosk-type centres in supermarkets or through the internet. If you have a speedy broadband connection from your PC, using an internet-based photo-lab offers the most convenient method of organising your output, without the expense and time taken out of your day to visit your local lab. An excellent service is available from UK-based internet lab Photobox. Here, you are given a sizeable 100Mb of space to call your own and the ability to display your work as you wish. The service works easily without any

special software through a simple web browser, where you transfer image files from your PC to the provider's server. As each image file chugs down your broadband or dial-up internet connection, you are left to get on with more interesting tasks.

Once arrived, you can organise your files into different folders and, most importantly, offer others a 'private' hyperlink to preview your work. The advantage of using this over a more family- orientated gallery space is that your viewers can then buy prints directly from your photo-lab hosted site, without the need for you to get involved.

A more sophisticated service is available from PhotoBox called Pro Galleries.

With no set-up charges, the service offers the added ability to set your own price for each product you sell via the site. An ideal way for any photographer to harness the convenience of an automated service and not get bogged down in administration. You set the print price for each item, then your client orders through the website and the provider gets a percentage of the sale. Ideal for press, PR and wedding photographers, you can set different prices for different clients and not have to pay upfront for anything.

The Lambda output device, shown right, offers silver-based output on a very large scale and can be used to generate the largest sized prints available.

Large-format output

Printing up to 44 inches wide, the large format inkjet printer can output onto a range of special media and is an economic tool for producing large print runs.

Designed initially for graphics studios, print bureaux and digital printing services, the large-format output device can now produce photographic-quality results. At this size, inkjet printers are manufactured around a basic four-colour CMYK inkset, or an advanced eight-colour inkset. Basic colour inksets are really only suitable for producing graphics such as posters, signage and CAD drawings. Photographic quality images printed with this kind of device will look crude when viewed close up, but will be perfectly adequate when viewed from a distance, as a point of sale display or signage for instance. Four-colour printers typically have a lower print resolution, with 1440 dpi being the maximum.

Photographic-quality large-format devices with eight colours are able to produce exhibition-quality prints by drawing on a wider colour range that includes light cyan, light magenta, light black and a light light black in addition to the four full-value CMYK colours. These kinds of printers have a higher output resolution of 2880 dpi and are able to minimise the amount of ink used by a clever variable-sized dot technology. This enables visibly smooth gradations of tone in the highlight areas of the print. To get the best out of different paper types, large- format printer manufacturer Epson have designed two types of black: a Matte

black for non-shiny surfaces and a Photo black for glossy surfaces. The cartridges are changed manually when switching between different paper types, ideally punctuated by the use of a cleaning cartridge to flush out residual inks.

To get the most cost-effective results from this kind of printer, a software raster image processor (RIP) can be used to arrange multiple prints on the full width of a section of roll paper. The drawback with RIP's are that they provide another layer of colour management issues to your workflow, increasing if a third-party application is selected instead of Epson's own. However, RIP's offer excellent value

in the long run, as they enable the user to manage large volumes of output in the most convenient manner. For very large print runs, a large-format device can be set to print overnight, thereby further increasing your productivity.

In addition to professional photographic and reprographic use, large-format printers are also used by many professional artists and fine art print studios. Able to edition photographic prints, digital illustration formats and produce point of sale displays using versatile media, as shown above, the large- format is the ideal tool for the ambitious professional.

Printing on-demand books

Making editions of your own digital books is simple and straightforward using a printing on-demand service.

The process of on-demand printing offers a dramatic cut in conventional printing costs. With no minimum print run or expensive outlay at the start, you only pay for the number of copies ordered, even if that means just one copy! In the process of researching this article, I made my own 30-page full-colour 8 x 6 inch book, perfect bound with thick, glossy laminated cover for nine pounds, four of which were for postage! This edition of just one was produced using a brand new online digital print-buying service from a US company called lulu.com.

The service is very simple and allows you to choose several different formats, finishes and extents for your book, all at a minimal cost to you, the client. While you input your data using a simple web browser at one end, there's a fully kitted up digital print station connected at the other, which takes your information and produces the book automatically by printing, binding and cutting. Using digital printing presses like the HP Indigo, which uses a dry toner ink rather than the traditional plates and solvent inks, the process is more similar to high quality photocopying than offset lithography. Yet despite the different technology, print quality is very good and you would be very unlikely to see the difference. Unlike traditional litho where you would need to pay for all scanning and then platemaking

before one single copy of your print was made, there are no set-up costs with a digital press, so you could order one copy or one hundred and the price per unit will remain the same. Most interesting, too, is the ability you have to customise your book to contain as few or many pages as you wish, the addition of each costing only a few cents more. Yet since digital print was introduced a handful of years ago, the quality of print and finish has improved remarkably. At best, when image files are properly prepared, the final print quality is indistinguishable from a conventionally printed coffee table book. At worst, printed images look somewhere between a good colour photocopy and a good inkjet print, with slight clumping in the shadows and a noticeable tonal jump from the darkest grey to black. However, with a document of carefully prepared images to test the printing services of Lulu, my results were very satisfactory indeed.

And the service doesn't end there. Once your book is created and signed off by you, it becomes available for purchase by others through the very same website. Just like buying a book from Amazon; lulu.com offers the same online sales service where you can set the cover price (higher than it cost you to produce, of course) and they take a small percentage from each sale. Each book you produce is listed within lulu.com's search engine and has its own

URL, so you can alert your buyers to exactly the right place to make a purchase. The majority of books within the store are specialist knowledge-based books, although there are plenty of picture-only books produced by budding travel photographers. When you create a book to print and release it for general sale, you can author a promotional paragraph and include a preview image of the cover to attract potential customers.

Potential uses

The availability of this service can really make you reconsider how you promote and publicise your own photographic work. For exhibition catalogues, you could easily pre-order fifty or so copies of a 25-page full colour book for around £250 and then recoup the cost of your outlay in book sales alone. Sometimes termed variable-data printing, this method of producing print without any set-up costs also allows you to produce ten unique books for the same cost as ten copies of the same book. Perhaps different cover images, content images or text could be used to personalise each version. A great way to close off a photographic project, the creation of a short-run book will give you tactile access to your work without turning on your PC or rummaging through a box full of prints.

house by
the lough

photographs by Tim Daly

Instantly more attractive than a postcard or business card to potential clients, a short-run book is a really smart way to promote your portfolio, the contents of which can be updated every time you order a new copy. Real treasures for a book collector will be copies of artist's books made in this way, perhaps limited to a handful of copies only.

Method of production

Despite the complexities of designing a book, where issues such as pagination, page numbering and layout can occupy your thoughts just as much as the content, meaning and message, designing a book for Lulu is very straightforward. Any desktop publishing design tool can be used to prepare the layouts, in conjunction with your favourite image editor such as Photoshop and a PDF creator. Your book is best prepared as a single document of many pages, rather than a collection of separate documents. The best layout tools to use are Quark or InDesign, but any other software tool will do as long as you can save or convert the file as a final PDF. Lulu requires you to create the inner pages of your book to match one of its pre-set sizes in either landscape or portrait format and this is easily achieved by selecting the Custom page size option in your DTP application. For the cover, only JPEG files are permitted, so you can create the entire design in Photoshop to the same dimensions as your inner book. At every stage of the production process, you can get a new quote if you decide to add or remove pages from your inner book, but the actual change in cost is really marginal. There are no restrictions on the number of images per page and you can

have images printed on both sides of each page if you wish, i.e. a book with 25 leaves can contain 50 images.

Design tips

The hardest part of making the document ready to upload, is the design. If you are not happy about fiddling with fonts and colours, then keep your page layouts simple and eye-catching. Allow a generous white border around each image, so your attention is focused entirely on the picture rather than the edge of the book and if you do decide to include text, keep it small and preferably on a facing page. Fonts are best very plain and should not distract. As the entire document is saved as a PDF, there are no limits on the kind or number of fonts you use in your final design. The service also allows you to create full bleed images, where the edge of your photograph butts up to the edge of your page and lulu.com suggests an

overlap of 0.5cm on the three sides subject to the guillotine's blade. From experimenting with the preparation of images in Photoshop for this service, the author prepared images with a resolution of 200 pixels per inch and kept sharpening to an absolute minimum. Images were fully corrected using Levels, but full blacks were knocked back a touch to allow for the possibility of gain in the shadows. In retrospect, even the images with an unusual tonal range reproduced well enough. Image files were prepared as TIFF's in the RGB colour space and re-sized to the exact size they would appear on the page. Once the size and position of the image on the page was decided, each image was simply imported in the DTP application and placed in a picture box. The difficult part of this process is deciding on the sequence of images in the running order for your book, but only you will know which image should follow

which. When preparing the cover JPEG documents in Photoshop, one for the front and one for the back, you are again allowed to bleed your design off, but with the suggestion that no critical text lies near the edges. Prepare your cover design using Photoshop's Type tool for ultra-crisp lettering with any colour that lies within gamut in the Photoshop Color picker.

Online help and upload

At every stage of your efforts, there are plenty of online hints and tips within the lulu.com website. In addition to supporting your book designs as PDF documents, the Lulu service will also accept your layouts uploaded as straightforward Microsoft Word, Lotus or Wordperfect files. Once uploaded through the browser, lulu.com converts your files into PDF's for you. Despite the convenience of this free service, this conversion can result in your layouts being changed from your original plan, especially when image and graphic files are included. A much better method is to lock your image files, special fonts and layouts into a PDF file that will not be altered by the on-demand service. Once your book is ready for upload, you first need to create a free account with lulu.com itself. Once established you are given a password and username and secure space to upload your documents. Once transferred (it is best if this is done via a faster broadband connection), you can view your documents online. Best of all is the option to preview your cover designs, with likely crop marks highlighted, so you can double check before ordering. This cover document is also available for you to download back to check at your leisure. Once uploaded, all

your PDF's are converted by lulu.com and given a unique reference number, which eventually denotes your book for future orders. There's no guesswork during this phase, as you are given every chance to view each component before committing.

Once accepted for print, you can order as many copies as you wish and for UK buyers, you can choose several different methods of postage. On testing, my first book took three weeks to arrive using the most basic postage service. You can then release your book for general sale to others on the site, or for an extra fee, opt for full ISBN registration. With this latter service, your book gets its own individual ISBN and barcode and can be sold to the wider world of Amazon.com customers in a joint arrangement with lulu.com. Once purchased, your title effectively becomes listed within the Amazon website and available to many more potential purchasers.

Production reference

Adobe's Portable Document Format, otherwise known as PDF, has established itself as a favourite way of transporting full-resolution layouts in the production of printed matter and is used throughout this convenient on-line service. Unlike freely downloadable PDF readers, such as Adobe Acrobat, a PDF creator is an extra piece of software that needs to be purchased as a separate item, although incorporated into full versions of InDesign and Quark from v6.0 onwards.

In addition to Adobe Acrobat retailing at around £220, cheaper options like the Jaws PDF Creator 3.0 at around £75 will do the same job for you. In addition to these full price applications, there are plenty of online PDF creators available for free, although none were tested for this article. Simply enter Free PDF in any search engine and you'll find a host of sites offering free PDF conversion.

Inkjet book kits

Ideal for making personalised albums, journals or even a diary, the inkjet book kit offers an alternative way of printing out your images.

A recent innovation on the market is the do-it-yourself inkjet book kit. Designed to offer you the chance to layout, print and bind your own book, they have become an increasingly popular alternative to printing on-demand books.

Good examples of inkjet book kits are made by Innova, who supply books of different sizes, shapes and with different paper types inside for you to use. These kinds of books avoid the complexities of sewn binding, using a simple screw post mechanism to hold together single sheets of perforated paper, as shown on the right.

To print out an album such as this, start by unscrewing the metal posts to detach the single sheets of paper from their vellum cover. Once each sheet is detached, it can be printed onto using your standard output technques, albeit using a custom paper size to allow for the three-centimetre strip which is perforated and separated from the page proper by a fold.

If no paper profile is available from the manufacturer, a good idea is to sacrifice at least one sheet, so you can run some tests off first.

Innova inkjet book are supplied with paper coated on both sides, so you could print a high number of images out in a relatively small scale book. With each book holding around 20 sheets of top quality inkjet paper, an inkjet book can be

an excellent way to present your work to a prospective client or interested party, or even simply to close out a personal project.

For this example project, an A4 Innova book was used which included acid- and lignin-free papers. The type of paper was a soft white art paper, similar to Somerset Velvet Enhanced, which gave the book an overall high quality feel. In addition to specific instructions on printer software settings, Innova also provided ICC profiles to support highest quality output from your home workstation.

Simple post books are very easy to make by hand, if you want a more hand-crafted feel to your books. Screw post fixings are available from all good bookbinding suppliers, leaving you the simple task of punching holes into the printing paper of your choice. Making your own books offers you the chance to use a selection of different paper types, perhaps interleaves of tissue paper and different colours for endpapers.

Weblink
www.innovaart.com

Chapter 9

STORAGE, MOUNTING AND DISPLAY

Archival storage and handling

Any expense that keeps your prints safe from contaminants and other environmental nasties, is a worthwhile investment.

A much less formal way of storing your prints safely and making them available for instant presention is to use archival products.

Long gone are the days when photographic prints were glued, taped or heat-bonded onto an assortment of card materials, now that we know more about the vulnerability of photographic print media.

Prints are mostly damaged by handling and can easily be spoiled by greasy finger marks, scratches or even ink stains from stray marker pens. In addition to visible physical damage, prints are also affected by UV light and atmospheric pollutants. Most of the effects of these contaminants can be significantly limited by the use of print sleeves and archival print storage boxes.

For inkjet prints, print sleeves offer an excellent way to preserve fragile or unstable images that are not destined for framing or exhibition. This can be achieved at roughly the same cost as the sheet of print paper that you are aiming to preserve.

Using such products, your work can be easily ready for any presentations that you need to make, allowing prints to be handled around a table without fear of any damage taking place. Best of all, your work remains in top-quality condition, in a dry environment free from any excessive humidity.

Polyester print sleeves

The best way of preventing physical damage to a fine print is to slip it into a polyester print sleeve, as shown above.

Available from all good professional photographic outlets, polyester print sleeves are available in most common paper sizes, with an additional half centimetre to allow for easy insertion and withdrawal.

Archival print storage box

Designed to accomodate polyester print sleeves, these archival stotage boxes are an ideal way to present individual prints to a client or for review.

Made from acid-free cardboard and in a simple clamshell design, as shown right, these offer suitable protection to your prints and can easily accomodate 20 to 30 sleeved pieces.

Print coatings

Designed to offer extra protection against airborne contaminants, water-based coatings can extend the life of your print.

Working in the same way as varnish applied to an old master painting, print coatings can increase the lifespan of your work. Available from all good ink and media manufacturers, these products are applied to your prints after they have dried sufficiently and effectively encapsulate the unstable ink within a sandwich of paper and coating.

However, although research has shown that longevity is increased by using these products, a similar increase in lifespan is gained when prints are mounted within a sealed frame. It is atmospheric pollutants that cause printing ink to deteriorate, not just excessive exposure to sunlight.

Coatings are used by many professional photographic printmakers to provide an extra guarantee for potential purchasers, so they can sell work with the same assurance as with a silver-based photographic print.

For smaller pieces of work, print coatings can be applied by brush, a technique which will raise the colour saturation of the print, just like a transparent varnish would do to an artist's paint on canvas.

Larger pieces are best sprayed with coating, using an air compressor within a booth with forced extraction. For large prints, it is best to apply sprayed coating using a sweeping motion, ensuring that the print is evenly coated across the surface.

Lifespan

Nowadays, the lifespan of digital prints compares favourably with silver-based media. Get into the habit of using the very best inks that you can afford, as they will ensure your print stays the course over time. Inks such as Epson's Ultrachrome offer exceptional lightfast properties and, when used with archival paper, are projected to last longer than a silver-based colour print.

Never choose the option of cheaper third-party inks, as these will have been prepared using unstable dyes and are available at a low cost because they were made from cheap ingredients in the first place. It's much better to print less with very good media and good pigment inks.

Another generic product worth avoiding is the undercolour removal software application. This works by limiting the amount of ink applied in the shadow areas of your print, essentially to save ink that would ordinarily build up into a dense black shadow. UCR is really technology adopted from the lithographic printing industry, where print products are never designed to last more than a few years at the very most.

Using UCR will save you ink, but will produce weak shadow areas where you would expect to see rich, deep colours and tones that enhance the image.

Lyson Print Guard

One of the first products to offer addditional protection from UV light and airborne contaminants, Print Guard is available as an aerosol spray. It's designed to work with most water-based inks and watercolour and provides a protective shield from the damaging effects of water. A typical application of Print Guard would be to spray your print two or three times, allowing it to dry in between applications, as shown right.

In addition to providing this kind of protection, Print Guard can also ward off excessive colour shift, due to prolonged exposure to light. A typical example of this occurred with non-lightfast inks which frequently faded in less than three months. Made from dye rather than pigment, these inks were so unstable, that each colour would fade at a different rate, resulting in prints that would turn into entirely green or cyan verisions of the original.

To ensure maximum protection from contaminants and to extend the lifespan of your print, it's essential to provide careful storage conditions to support any coatings that you apply.

Avoid chemicals at all cost, such as adhesives or cheap cardboard, as these will likely contain harmful bleaches and dyes that could damage the delicate surface and colour balance of your print.

Mounting monochrome

Presenting your work can be a tricky process and one that needs proper care and attention to bring out the best in your photographic prints

After spending time shooting, processing and printing out your photos, you should be ready to invest a little time on the final stage of presentation. When purchasing frames, there's plenty of choice in the pre-assembled range from most department stores that are designed to properly display photographic images produced in the standard A3 and A4 sizes.

For those with more unusual print shapes, bespoke frames can be purchased at a specialist framers for a little more outlay. Inside the frame, photographic prints look much better when they are mounted within a hinged window mount which provides a border between the frame edge and image and this also provides a much-needed barrier so the print doesn't touch the glass.

Framing monochrome

Black frames and white mounts work best for neutral monochrome prints, but if you have toned your work, then use a tinted mountboard too. Warm-tone prints look sensational if they are mounted on neutral brown card as the card colour seems to make the print look more toned. Avoid bright colours at all costs and also ultra-bright whites, especially if your printing paper is cream or off-white. Richly coloured woods are an ideal framing material for toned monochrome prints, as shown right.

Border size
Shown above is a good example of a generous border size, which allows you to appreciate the original composition of the print. Too small and the frame will start to be part of the piece.

Coloured mount ⋯⊹
A different way of mounting your work is to use a sympathetic coloured mount, as shown right. The best colours enhance the natural print colours, especially if they have been toned.

Mounting colour

Colour images can be mounted in lots of different colours, shapes and frames to further enhance them.

Choosing a frame

Neutral frame colours work best, such as black, brown or natural woods as they don't steal attention away from your work and they provide a much more flattering surround than the cheaper clip-frames. Aim for a size that is at least 50% larger than your print in both dimensions.

Framing colour photos

Depending on the nature of your image, always try to use a complimentary mounting. By choosing darker wood frames you are effectively enhancing the rich colours of your photo print. Off-white window mounts work best and look good if plenty of white space surrounds the print.

Mount composition

If you cut your own mounts, you'll get a much better result if you leave a deeper border on the bottom edge. When measuring up, always make the top, left and right edges the same width and leave the bottom one slightly deeper. If all borders are the same, a curious visual illusion occurs which makes the bottom border look smaller.

Sunlight and fading

To minimise the risk of fading, never position your frames in direct sunlight, as the less stable colours will start to fade. When printing up your work, always examine your test prints under the same lighting in which they will be displayed. This is because prints can appear to change colour when viewed under fluorescents and take on a slightly green tone.

Mountboard colours ⋯⁖

Shown right are several different colours of mountboard around a richly coloured photographic print. Strong midtone colours work best, as these accentuate the bright highlights of the final print.

Exhibition framing

The final stage of presenting your work to an audience is mounting and framing, both easily achieved with a minimum of special equipment.

Framing benefits

In addition to making your prints look professionally finished, framing and mounting offer several other important benefits. All photographic prints are vulnerable to physical and environmental damage when in preparation and can easily be spoiled by contaminants. Inkjet prints are especially vulnerable to exposure to UV light and atmospheric pollutants and their life expectancy is radically increased once sealed behind glass in a well fitted frame.

Once your print has been gently inserted into a window mount cut from archival mount-board (avoiding the use of all adhesives, of course), the window mount serves two important functions. Firstly it keeps the print flattened and prevents excessive buckling and, secondly, it provides a small buffer between print and glass.

Any photographic print, be it silver-based, inkjet or dye-sublimation, will deteriorate easily if it is squashed against a sheet of glass, as in a clip-frame. On the reverse side of the frame, after the mount and backing board have been inserted, a thick band of gummed tape should be applied. Available from all art shops and primarily used for stretching paper, gummed tape provides an important seal against moisture and other airborne contaminants.

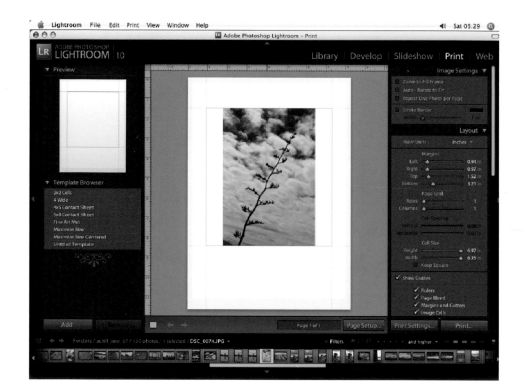

Art matting in Lightroom

Shown above are the excellent Print module controls featured in Adobe Photoshop Lightroom. The extensive dialog allows you to drag precise borders around your image, depending on the target print paper size.

This function enables you to previsualise the appearance of the final print in a much better way than any basic print preview function could ever hope to do.

Window mount ⋯⋮

A finished window mounted print, by photographer Paul Daly, showing a generous gap between the edge of the image and the mount. Such an example demonstrates how the inclusion of part of the blank white printing paper helps to change the perception of a print from a simple 'window on the world'. By allowing the edges of the printing paper to be visible, the print itself comes to be perceived as precious object.

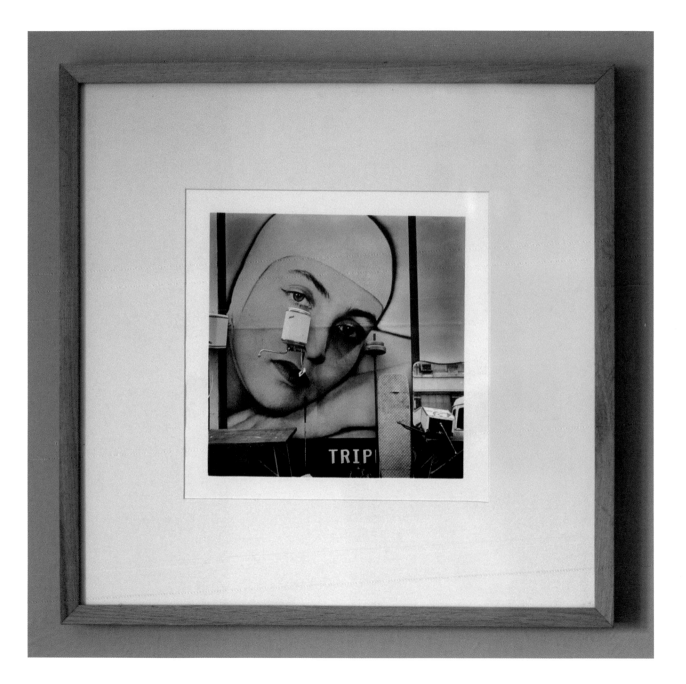

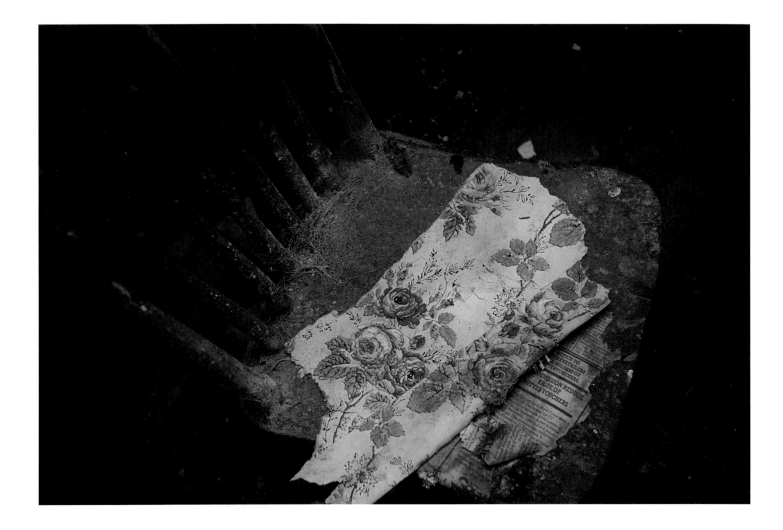

Chapter 10

MONITORING IMAGE QUALITY

···> Print viewing

···> Clipping warnings

···> Soft-proofing functions

···> Desktop densitometer tools

···> Sharpening

···> High-resolution enlarging

Print viewing

If your digital photos keep turning out with a curious colour cast, it could be because you are not viewing your test prints in a colour-controlled environment.

The working environment

If you've got the luxury of a permanently housed digital darkroom in your home, then you need to make sure that it's set up correctly. All image-editing work can be affected adversely by the influence of extraneous light and colour, so the first task in designing the ideal workspace is to achieve consistent levels of illumination.

Most domestic rooms get light from windows which provide varying intensities and colours of light throughout the day. Windows are best covered in a blackout blind so an even level of lighting is produced by your artificial sources. Aim for a level of room illumination that is lower than the brightness produced by your monitor, or you'll struggle to judge tone and colour onscreen.

No saturated colours should be used to paint the walls of your workshop and bright white should be avoided too. The best option is to paint your walls in a matt, neutral grey colour with 60% reflectance. This colour comforts to the Munsell 8 grey as a reference for your local paint supplier.

Always avoid placing your monitor where reflections from windows or light sources will appear and avoid placing any kind of brightly coloured objects in your working environment, including your own clothing. This explains why many imaging professionals wear only black!

Viewing conditions

The best way to start off your colour-balancing process is to ensure that you are viewing your prints in a colour-controlled environment. Viewing prints under domestic tungsten lightbulbs will not allow you to make accurate judgements as the colour termperature of this light source is variable.

A much better option is to invest in a form of colour-calibrated lighting that conforms to a common international standard.

The D50 lighting standard is a universal guide for those products that adhere to a neutral colour temperature of 5000K. This standard is gaining increasing acceptance in the professional environment as the most acceptable source to preview prints under. With a colour that is neutral to the human eye, the D50 standard should be your ideal starting point

Depending on your budget, the process can be as simple as replacing the fluorescent tubes in your workspace with D50 compliant tubes, or investing in a specially calibrated viewing booth. Built like a box with one side open and illuminated from above, the viewing booth creates a completely controlled lighting environment which remains unaffected by ambient light. By placing your prints inside the box, you can be assured of judging in the cleanest of light environments.

Most professional output studios have a colour-controlled viewing booth, like the Just Normlicht example opposite, manufactured in various sizes and with an optional illuminated light source for viewing transparency material, rather than a reflected light source.

If your budget doesn't stretch to a purpose-built booth, then consider changing the artificial light source in your workspace. When thinking about artificial illumination, don't forget that the human eye has the most advanced automatic white-balance correction facility, so you will very rarely be aware of a non-continuous visual spectrun.

Domestic tungsten bulbs are perhaps the worst option for colour print viewing, as they are set at the warmer, red end of the scale. The ubiquitous fluorescent tube can also be problematic with a myriad of descriptors to choose from, including daylight, warm white and cool white to name but a few. Fluorescents can also emit a different colour temperature as they age and even as they crank up to their normal working brightness. After installation, don't forget that any light modifiers placed between you and the bulb, like a diffuser or reflector will also influence the final colour.

For the best solution, talk to your local industrial lighting wholesaler, or even your local digital pro-lab to find their brands.

Clipping warnings

Clipping warnings can be viewed throughout shooting and desktop editing, to warn you of potential problems further down the line.

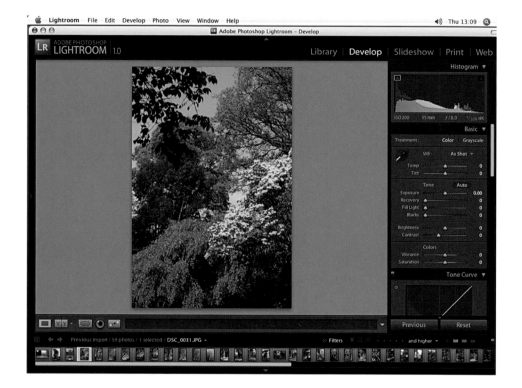

In-camera clipping warnings

All digital SLR's and top quality compacts offer the useful benefit of a Levels histogram when an image is played back on the rear LCD preview monitor, so you can see exactly how an image has been recorded.

If you find it hard to judge in the field, whether your image file is over-exposed, you can check its histogram to make sure. The histogram shows the quantity of pixels on the vertical scale together with their brightness values along the horizontal scale. In the example shown above, there are excessive highlights recorded on the right edge of the histogram, suggesting that an alternative exposure should be chosen.

At the left-hand end of the graph is the shadow point with the highlight point set at the opposite, right, side. As each image is recorded, it is possible to judge exposure just by looking at the histogram. If this function is not available on your SLR, it can be checked in the Levels dialog.

Clipping warnings in Lightroom

To judge the amount of tonal clipping, or those parts of the image which are devoid of any detail, two tiny upturned triangles are shown at the top left and right corners of the Histogram dialog, as shown above. The triangle at the top left is for shadows and one at the top right is for highlights.

In the default position, clipping remains turned off, but if you float your cursor over either triangle, the Clipping Marker colour appears instantly in the image. To turn the

Clipping Marker on permanently, simply click on either upturned triangle until it shows a thin white border.

With the clipping marker turned on, all instances of over-editing will be coloured blue, as shown in the preview image in the above screengrab.

Clipping Markers are there to warn you about areas of your future print that will not contain detail, so you are armed with the implications of your editing and can reverse out, or change tactics altogether.

Gamut warnings in Photoshop

A monitor displays colour in a different way to the way a printer outputs coloured ink on paper. The monitor transmits richly saturated coloured light via RGB phosphors, but print-outs reflect less vivid colours. Each stage in the capture, processing and output of a digital photo has its own unique range of colours called a gamut, better imagined as a palette.

If you've frequently been disappointed by the difference between print-out and display, it's because you are trying to exceed the range, or gamut, of your ink and paper combination. By using Photoshop's Gamut warning functions, you can make a better prediction of potential mistakes before you waste paper and ink.

Photoshop allows you to increase the colour saturation of an image very simply, but this will never translate to your print-outs with the same intensity. These over-ambitous colours are detected by switching on the Gamut Warning option, found in the View menu. Once switched on, the Gamut Warning option is left on for the duration of your work and works by tagging a drab grey colour, all colours unlikely to print as they appear.

This grey is not embedded in your image file, but acts purely as a marker and won't print-out. As you work steadily, the Gamut Warning will show up only when you try and stretch colour saturation or use special colour palettes such as the Pantone ranges, which frequently can't be reproduced by inkjet printers. It's a much better idea to have the Gamut Warning selected from the outset, because smaller problems can be dealt with on the spot rather than trying to tackle an insurmountable problem at the very end of your work.

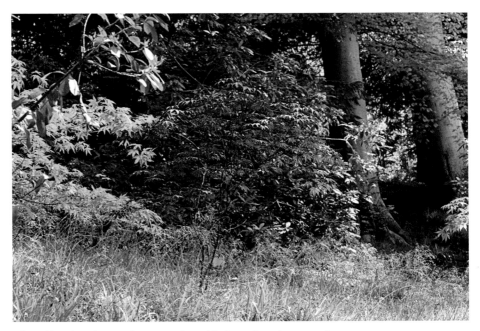

This richly coloured image above was enhanced by increasing colour saturation

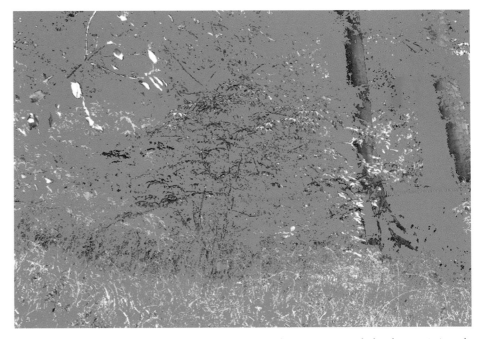

Yet, once Photoshop's Gamut Warning was switched on, most of the image was marked with non-printing values

Soft-proofing functions

Photoshop offers an ideal way to predict the likely outcome of your print from the convenience of your desktop, through its soft-proofing functions.

In the complex and costly world of commercial printing, taking risks can be an expensive mistake. Yet if you could see into the future and predict exactly how your work in progress will print-out, you could save yourself a lot of time and aggravation.

Exactly the same issue needs addressing when making inkjet prints on your desktop system: just how do you prepare an image if Photoshop doesn't know how a sheet of Epson paper will respond to your file. Well, surprisingly, Photoshop does know and can display the likely result as a soft-proof preview

Soft-proofing essentials

If different input and output devices can have their own dedicated colour profiles, there's no reason why a paper and ink combination can't follow suit. At the time of installation Photoshop is loaded with a huge number of profiles which correspond to input, display and output devices. Surprisingly, Photoshop also builds up a library of new profiles each time you install new printer or scanning software.

Supplied by the printer manufacturer to help you pre-visualise the likely results of printing on their papers, paper profiles are well worth investigating. These profiles can be called into play when you want to use a particular type of print paper and, most importantly, predict the likely outcome.

Just as the Gamut Warning predicts non-printing colours, the soft-proof preview mimics the likely look of the printed version on your monitor. Like all colour-management features, this function is only worth using if you have already established colour settings and calibrated your monitor first.

Setting up the soft proof

Go to View····⟩Proof Setup····⟩Custom and check the Preview button so you can see the change as it happens. In the Profile drop-down, click and hold until you can pick the colour profile that matches the media chosen to output your image. The profiles you will have on your machine will depend on the version(s) of printer software you've installed. If you carry this command out without an open image file, it will become your default soft-proof.

Defining the settings

After choosing the profile, return to the dialog box and deselect the Preserve Colour Numbers. Next, from the Intent drop-down menu, choose the Relative Colormetric option as your rendering intent. A rendering intent dictates how your colours are mapped from one colour space to another. Finally, choose Black Point Compensation and Simulate Paper White.

Selecting the soft-proof view

With the View····⟩Proof Colours function selected, the soft-proof image is now shown. You can tell if you are viewing a soft-proof as its name will be displayed on the top of your image window next to the image mode following a forward slash. As new printer software is added, or bespoke ICC profiles, these too will become options in the Proof Setup Custom dialog box.

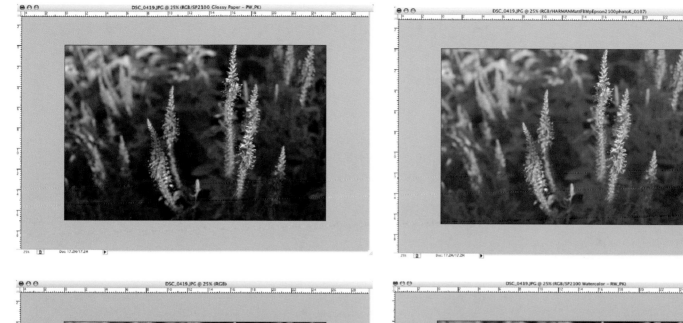

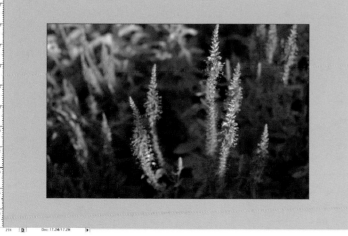

Four soft-proofs

These four screengrabs show the result of proofing an image against four very different paper mediums. In the top right example, see how the soft-proof anticipates lower contrast and colour saturation.

Desktop densitometer tools

Photoshop's Color Sampler tool is a useful gadget for detecting colour values within your image. Like a mini-densitometer, the samplers can be attached to critical areas of your image to provide a real-time read out.

In addition to Photoshop's Gamut Warning and soft-proofing functions, there exists a further desktop device for you to monitor excessive shifts in colour or tone. The Color Sampler tool is effectively a mini-densitometer, able to detect subtle changes and modifications to your image as you work through a project.

The Colour Sampler tool is used by experienced printers who, from the outset of a project, know where the likely danger areas are in an image. Examples of this are ultra-bright highlights that were burned-out in an exposure, or shadows without any visible detail.

The purpose of the tool is to make you aware of any significant alterations to your colours or tones as you edit creatively, as there's not much point in getting to an end- state if it won't print out as you expect.

The tools are simple to use and apply. First pick the tool up from the toolbox then click it down into an area of your choosing. Next, ensure that the Info dialog box is open on your desktop, as this provides the readout from each individual sampler.

You can apply a maximum number of four samplers to any one image at a time. They are easily moved by clicking onto the icon and dragging it into a new position. The samplers don't print out, of course and can be easily switched on and off by using the Clear command.

Setting the Info Palette ⋯⁃

The Info Palette is clustered together with Photoshop's Navigator and Histrogram palettes and offers much useful information. When used in conjunction with the Color Sampler tool, it generates four additional quarters, as marked right in blue. By default the read outs are decribed in RGB terms on a scale of 0-255, but you can change this to a simpler 0-100 scale by clicking on the tiny dropper icons within each of these four squares. Once in the pop-up menu, choose the Greyscale option. For each numbered sampler placed within your image, a corresponding read-out is generated in the Info Palette which changes every time you make an edit.

Setting the sample size

By default the Color Sampler will be set to give a read-out based on the colour or tone of a single pixel. This can however, be very misleading, as pixel colour varies enormously even within a small and evenly coloured area of your image.

A much better option is to set the sample size to produce an aggregate read out from a larger area of pixels, such as 3 x 3, 5 x 5 or 11 x 11. By working with an average read out, you are assured that it's the general area underlying the sampler that is changing rather than the colour of a single near-invisible pixel.

Doc: 17.2M/17.2M

Click image to place new color sampler. Use Cmd for additional options.

Work in progress ⋯⁃

This desktop screenshot shows the use of three Color Samplers, positioned in critical areas of the image. The first sampler is placed in the top left of the image, on a bright highlight. The second sampler is placed in the bottom right quarter of the image to monitor the shadow areas. The third and final sampler is placed on the most saturated colour in the image, in this case a bright blue, to monitor any out-of-gamut increase.

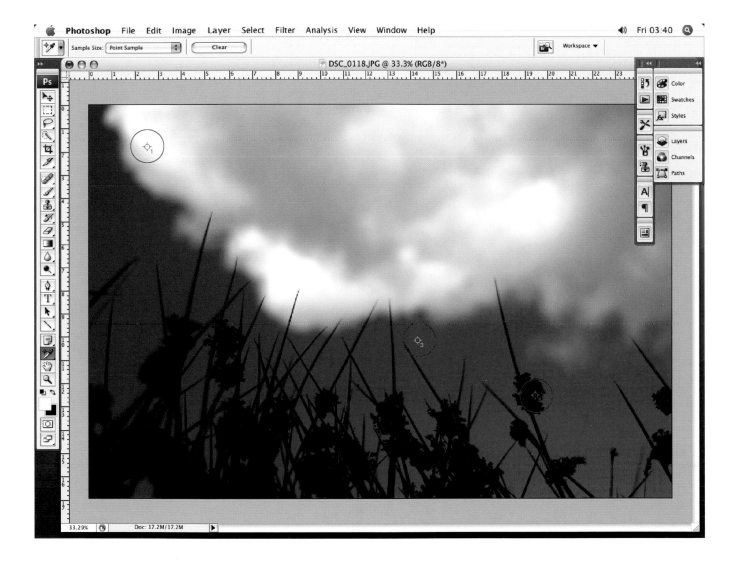

Sharpening

All digital prints will benefit from some sharpening, but the trick is knowing how much to apply to get the best results out of your chosen media.

The magical sharpening tools can be used to tweak an image into fine focus, but can't be used to correct camera shake or badly focused work. Sharpening is nothing more than increasing the level of contrast between edge pixels. In a soft-focused image, colours are muted at the edges of shapes, but in a pin-sharp example colours are more differentiated and have inherently more contrast.

All images benefit from software sharpening, applied as the final stage just before the printing. Applied too early in an edit, artifacts caused by sharpening will become magnified and destroy image quality. All image should be sharpened after resizing in either directions, as interpolation causes an inevitable loss of original image detail.

Early versions of Photoshop are supplied with four sharpening filters, Sharpen, Sharpen More, Sharpen Edges and the Unsharp Mask, all of which can be applied to the image overall or to a smaller selection area. Only the Unsharp Mask filter can be modified to address the exact problems posed by individual images.

The Unsharp Mask filter

Found under the Filter····⫸Sharpen····⫸Unsharp Mask command, the USM has three controls: Amount, Radius and Threshold. Amount describes the extent of the change of pixel colour contrast. The Radius slider is used to determine the number of pixels surrounding an edge pixel, with low values defining a narrow band and high values creating a thicker edge. The final Threshold modifier is used to determine how different a pixel should be from its neighbours before sharpening is applied. At a zero threshold, all pixels in an image are sharpened, resulting in a noisy and unsatisfactory image. Set at a higher value, less visible defects will occur overall. As a guide, start with Amount 100, Radius 1 and Threshold 1. If this looks too sharp, reduce the Amount to 50.

Paper types and sharpening

Each paper type and surface has a unique capacity to hold an optimum number of ink droplets. Uncoated papers are less able to hold distinct inkjet dots separately on the page, thereby producing a more softly focused result. Purpose-made coated inkjet media can hold the maximum number of separate ink dots and produce the sharpest results.

When planning your USM routine, it's essential to take into account the type of print media, as no amount of sharpening can improve the print quality of absorbent media. On the other hand, high levels of sharpening can be applied to high-resolution files output onto specially coated materials.

The Smart Sharpen filter

A recent introduction to Photoshop is the new Smart Sharpen filter, as shown above. This tool offers you advanced controls for maintaining sharpness in your images, using the same familiar USM controls, but with the ability to control sharpening in the highlights and shadow areas.

Applying USM by brush

Using an identical method to that described on page 72, sharpening can be applied using the History brush tool. This process is ideal for applying sharpening to specific areas.

Sharpening in practice ····⫶

This image, right, was edited as follows: a: unsharpened; b: Amount 50, Radius 1 and Threshold 1; c: Amount 100, Radius 1 and Threshold 1; d: using the Smart Sharpen settings as shown in the above dialog box.

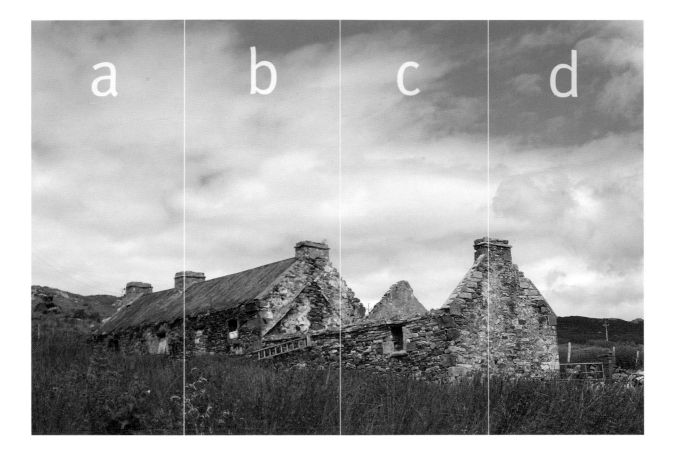

High-resolution enlarging

Genuine Fractals is a useful Photoshop plug-in that employs an innovative method for scaling up digital images for poster-sized print outs.

Mathematical genius

Digital images are captured with a fixed pixel dimension such as 800 x 600 or 3000 x 2000 and this determines the size of photo-realistic print that you can output. Most inkjet prints look photo-realistic with around 200 pixels per linear inch of print, so it follows that a 3000 x 2000 pixel file can be output at a maximum size of 15"x 10".

Should you want to enlarge your print beyond this size, you will need to add new pixels to your file by a process called resampling or interpolation. All photo-editing software allows you to resample using a common mathematical formula, or algorithm, called bicubic interpolation. Essentially, the colour of each additional pixel is estimated by averaging out the colour values of the surrounding original pixels and the results look acceptable up to 120% of the original size. Anything over that enlargement then starts to lose sharpness as the quantity of additional pixels starts to increase. The downside of bicubic interpolation is that the process doesn't indentify shape edges, which causes the characteristic loss of sharpness.

Genuine Fractals is an interesting tool because it uses a completely unique algorithm to estimate the values of new pixels, by looking for repeated patterns in your image called fractals. Once detected, these patterns can be scaled-up without such a drop in quality.

Using Genuine Fractals

Open your image in the plug-in and watch the desktop interface appear, as above. On the right-hand side are displayed the current pixel dimensions of the file and the target print or output dimension.

Simply resize these values to your intended enlargement, or choose one of the preset document sizes from the drop-down menu, if you can't remember the exact sizes. This process allows you to lock the relative vertical and horizontal dimensions, so you don't create a distorted enlargement.

Improving quality

Recent versions of Genuine Fractals have a useful Texture Control panel, where you can improve the results of enlarging by using two modifiers: Amount and Threshold. Use the Amount slider at 3 or below when your image has large areas of flat tone and few edges and use 4 to 5, where your enlargement contains lots of small detail or patterns.The Threshold settings determine the amount of hard-edged detail that is enhanced. Use 25 or less for images with less detail, 50 or above for more detailed subjects.

Comparing end-results

The same image was enlarged twice, shown right top, using Genuine Fractals, and right bottom, Photoshop's bicubic method. The original file measured 3000 x 2000 and the enlargement was set at a gigantic 8267 x 5497!

The expected results from the bicubic method would be an overall loss of detail and sharpness at the edges of individual shapes and this is very much borne out by the screenshot.

On the other hand, the same image as enlarged by the Genuine Fractal plug-in shows a marked improvement in sharpness. Looking closely at the regularly patterned areas, such as the brickwork, these are much more defined that the bicubic example.

In addition to the Resizing and Texture tools found in Genuine Fractals, the latest version of the plug-in contains the now familiar Unsharp Masking tools, so you could streamline your workflow in the one dialog box, should you be creating images for immediate output to a large-format printer.

Enlarged using Genuine Fractals Photoshop Plug-in

A close-up detail of the fractal algorithm in action

Enlarged using Photoshop's bicubic interpolation method

Jargon buster

Artifacts
By-products of digital processing, like noise, which degrade image quality.

Aliasing
Square pixels describe curved shapes badly and look jaggy close-up . Anti-aliasing filters and software lessen the effects of this process by reducing contrast at the edges.

Background printing
A way of letting an image document print while still retaining the ability to work in the current application.

Batch processing
Using a special type of macro or Action file, batch processing applies a sequence of preset commands to a folder of images automatically.

Bit
A bit is the smallest unit of data representing on or off, 0 or 1, or black or white.

Bitmap image mode
Bitmap image mode can display only two colours, black and white, and is the best mode to save line art scans. Bitmap images have a tiny file size.

Bitmap Image
A bitmap is another term for a pixel-based image arranged in a chessboard-like grid.

Byte
Eight bits make a byte in binary numbering. A single byte can describe 0–255 states, colours or tones.

Card reader
Digital cameras are sold with a connecting cable that fits into your computer. A card reader is an additional unit with a slot to accept camera memory cards for faster computer transfer.

CCD
Charged Coupled Device is the light-sensitive 'eye' of a scanner and 'film' in a digital camera.

CDR
Compact Disk Recordables store digital data and are burned in a CD writer. With a capacity of 640Mb, CDRs are a very low-cost way to store digital images.

CDRW
Compact Disk Rewriteables can be used many times, unlike CDRs which can only be burned once.

CIS
Contact Image Sensor is a recent alternative to CCD in scanning technology, giving higher-resolution values but using different measuring criteria.

Clipping
Clipping occurs when image tone close to highlight and shadow is converted to pure white and black during scanning. Loss of detail will occur.

CMYK image mode
Cyan, Magenta, Yellow and Black (called K to prevent confusion with Blue) is an image mode used for litho reproduction.

Colour depth
This describes the size of colour palette used to create a digital image, e.g. millions of colours.

Colour space
RGB, CMYK and LAB are all kinds of different colour spaces with their own unique characteristics and limitations.

Compression
Crunching digital data in smaller files is known as compression. Without physically reducing the pixel dimensions of an image, compression routines devise compromise colour recipes for groups of pixels, rather than individual ones.

CPU
The Central Processing unit is the engine of a computer, driving the long and complex calculations when images are modified.

Curves
Curves is a versatile tool for adjusting contrast, colour and brightness.

CRT
A cathode ray tube is the light-producing part of a monitor.

Diffusion dithering
A dithering technique allocates randomly arranged ink droplets, rather than a grid, to create an illusion of continuous colour.

Dithering
A method of simulating complex colours or tones of grey using few colour ingredients. Close together, dots of ink can give the illusion of new colour.

DIMM
Dual Inline Memory Modules are a kind of RAM chip, sold with different capacities, e.g. 128Mb, and with different speeds.

Digital zoom
Instead of pulling your subject closer, a small patch of pixels is enlarged or interpolated to make detail look bigger than it really was.

Dropper tools
Pipette-like icons that allow the user to define tonal limits like highlight and shadows by directly clicking on image areas.

Dye sublimation
A kind of digital printer that uses a CMYK pigment-impregnated ribbon to press colour onto special receiving paper.

Dot pitch
A measure of the fineness of a CRT monitor's shadow mask. The smaller the value, the sharper the display.

DPI (scanner)
Dots per inch is a measure of the resolution of a scanner. The higher this number is, the more data you can capture.

DPI (printer)
Printer DPI is an indication of the number of separate ink droplets deposited by a printer. The higher the number, the more photo-real results will look.

Duotone
A duotone image is constructed from two different colour channels chosen from the Colour Picker and can be used to apply a tone to an image.

Driver
A small software application that instructs a computer how to operate an external peripheral like a printer or scanner. Drivers are frequently updated but are usually available for free download from the manufacturer's website.

Dynamic range
A measure of the brightness range in photographic materials and digital sensing devices. The higher the number, the greater the range.

EPS
Encapsulated Postscript is a standard format for an image or whole page layout, allowing it to be used in a range of applications.

File extension
The three or four letter/number code that appears at the end of a document name, preceded by a full stop, e.g. landscape.tif. Extensions enable applications to identify file formats and enable cross-platform file transfer.

FireWire
A fast data transfer system used on recent computers, especially for digital video and high-resolution image files. Also known as IEEE1394.

Gamma
The contrast of the midtone areas in a digital image.

Gamut
A description of the extent of a colour palette used for the creation, display or output of a digital image.

GIF
Graphics Interchange Format is a low-grade image file for monitor and network use, with a small file size due to a reduced palette of 256 colours or less.

Grayscale
Grayscale mode is used to save black and white images. There are 256 steps from black to white in a grayscale image, just enough to prevent banding appearing to the human eye.

Halftone
An image constructed from a grid of dots of different sizes to simulate continuous tone or colour. Used in magazine and newspaper publishing.

Highlight
The brightest part of an image, represented by 255 on the 0–255 scale.

Histogram
A graph that displays the range of tones present in a digital image as a series of vertical columns.

ICC
The International Colour Consortium was founded by the major manufacturers in order to develop colour standards and cross-platform systems.

Inkjet
An output device which sprays ink droplets of varying size onto a wide range of media.

ISO Speed
Photographic film and digital sensors are graded by their sensitivity to light. This is sometimes called film speed or ISO speed.

Interpolation

Enlarging a digital image by adding new pixels between existing ones.

Jaggies

See Aliasing.

JPEG

A compression routine used to reduce large data files for easier transportation or storage. Leads to a reduction in image quality if files are repeatedly opened and re-saved.

Kilobyte (K or Kb)

1024 bytes of digital information

LAB image mode

A theoretical colour space used in Photoshop for image processing, but not employed by any camera or printing device.

Layered image

A kind of image file, such as the Photoshop file, where separate image elements such as text and image can be arranged above and below each other, like a stack of cards.

Layer blending

A function of Photoshop layers, allowing a user to merge adjoining layers based on transparency, colour and a wide range of non-photographic effects.

Layer opacity

The visible 'strength' of a Photoshop layer can be modified on a 0–100% scale. As this value drops, the layer becomes semi-transparent and the underlying layer starts to show through.

Levels

A set of tools for controlling image brightness found in Adobe Photoshop. Levels can be used for setting highlight and shadow points.

Line art

A type of original artwork in one colour or tone only such as typescript or pencil drawings

Megapixel

Megapixel is a measurement of how many pixels a digital camera can make. An image measuring 1800 x 1200 pixels contains 2.1 million pixels (1800 x 1200=2.1 million), or 2.1 Megapixels

Megabyte (Mb)

1024 kilobytes of digital information. Most digital images are measured in Mb.

Noise

Like grain in traditional photographic film, noise is an inevitable by-product of shooting with a high ISO setting. If too little light passes onto the CCD sensor, brightly coloured pixels are made by mistake in the shadow areas.

Optical resolution

Also called true resolution, this is a measure of the hardware capability, excluding any enhancements made by software trickery or interpolation.

Pantone

The Pantone colour library is an internationally established system for describing colour with pin-number-like codes. Used in the lithographic printing industry for mixing colour by the relative weights of the four process colour inks.

Path

A path is a vector-based outline used in Photoshop for creating precise cut-outs. As no pixel data is involved, paths add a tiny amount to the file size and can be converted into selections.

PCI Slot

A Peripheral Component Interface Slot is an expansion bay in a computer used for upgrading or adding extra connecting ports or performance-enhancing cards.

Peripherals

Peripherals, like scanners, printers, CD writers etc, are items used to build up a computer workstation.

Pigment inks

A more lightfast inkset for inkjet printers, usually with a smaller colour gamut than dye-based inksets. Used for producing prints for sale.

Pixel

Taken from the words Picture Element, a pixel is the building block of a digital image, like a single tile in a mosaic. Pixels are generally square in shape.

Process colours

The term used to describe the four standard ink colours Cyan, Magenta, Yellow and Black, used in lithographic printing.

Profile

The colour-reproduction characteristics of an input or output device. This is used by colour-management software such as ColorSync to maintain colour accuracy when moving images across computers and input/output devices.

Quadtone

A quadtone image is constructed from four different colour channels, chosen from the Colour Picker or custom colour libraries like Pantone.

RAW

The term RAW describes an image file that has been captured and stored in an unprocessed state. RAW files must be opened in special applications such as Lightroom before editing.

RAM

Random Access Memory is the part of a computer that holds your data during work in progress. Computers with little RAM will process images slowly as data is written to the hard drive, which is slower to respond.

RIP

A Raster Image Processor is used as an alternative printer driver when sharing a printer on a network or outputting jobs simultaneously on a large format printer. RIP's can be both hardware and software.

Resolution

The term resolution is used to describe several overlapping things. In general, high-resolution images are used for printing out and have millions of pixels made from a palette of millions of colours. Low-resolution images have fewer pixels and are only suitable for computer monitor display.

RGB image mode

Red, Green and Blue mode is used for displaying colour images. Each separate colour has its own channel of 256 steps and pixel colour is derived from a mixture of these three ingredients.

Selection

A fenced-off area created in an imaging application like Photoshop which limits the effects of processing or manipulation.

Scratch disk

A portion of a computer's free hard disk (or an external drive) that acts as overflow RAM during work in progress.

Shadow

The darkest part of an image, represented by 0 on the 0–255 scale.

Sharpening

A processing filter which increases contrast between pixels to give the impression of greater image sharpness.

Unsharp Mask (USM)

This is the most sophisticated sharpening filter, found in many applications. Recent versions of Photoshop offer an enhanced kind of USM called Smart Sharpen.

USB

Universal Serial Bus is a recent type of connector which allows easier set-up of peripheral devices.

TIFF

Tagged Image File Format is the most common cross-platform image type used in the industry. A compressed variation exists which is less compatible with DTP applications.

Tritone

A tritone image is constructed from three different colour channels, chosen from the colour picker or custom colour libraries like Pantone.

TWAIN

Toolkit Without An Interesting Name is a universal software standard which lets you acquire images from scanners and digital cameras from within your graphics application.

White balance

Digital cameras and camcorders have a white-balance control to prevent unwanted colour casts. Unlike photographic colour film, which is adversely affected by fluorescent and domestic lights, digital cameras can create colour-corrected pixels without using special filters.

White Out

In digital images, excessive light or overexposure causes white out. Unlike film, where detail can be coaxed out of overexposed negatives with careful printing, white pixels can never be modified to produce latent detail.

VRAM

Video RAM is responsible for the speed, colour depth and resolution of a computer monitor display. A separate card can be purchased to upgrade older machines with limited VRAM.

Index

Contacts and credits

Further tuition

Tim Daly also runs Photocollege, the online learning centre for photography and photo-imaging.

Photocollege provides online tuition for a wide range of photographers and creative industries professionals on topics including colour management, digital printing, Lightroom and Photoshop.

Visit the website on:
www.photocollege.co.uk

Contact the author by email on:
timdaly@photocollege.co.uk

Friends and supporters

The author would like to thank the following family and friends for their invaluable help in the research and production of this book:

Nina Daly for book design.

Piers Burnett and Eddie Ephraums at Argentum.

Chris Dickie, Editor of Ag: The Journal of Photographic Art & Practice.

Philip Andrews, editor of Better Photoshop Techniques.

Suppliers

The author would also like to thank the following suppliers for their advice and support in the research for this book:

Adobe
Adobe Photoshop CS3 and Lightroom software applications.
www.adobe.com

Epson
Stylus Photo 4800 and Ultrachrome Inks and print media
www.epson.co.uk

Innova papers
Inkjet book kits
www.innovaart.com

Colour Confidence
Gretag Macbeth Eye-One monitor calibration and print profiling equipment
www.colourconfidence.co.uk

Hassleblad UK
Imacon Flextight scanner

InkAid
Liquid Inkjet coatings
www.inkaid.com

Harman Technology
Baryta papers
www.harman-inkjet.com